EISENSTAEDT : GERMANY

EISENSTAEDT
GER

PUBLICATION MADE POSSIBLE BY A GRANT FROM UNITED TECHNOLOGIES CORPORATION

MANY

Eisenstaedt : Germany containing 94 photographs taken
mostly in Germany from 1913 to 1980, with appreciations by
Joshua C. Taylor and Klaus Honnef.

Editor : Gregory A. Vitiello
Art director and designer : Derek Birdsall

International Standard Book Number : 0–8109–0954–5
Library of Congress Catalog Card Number : 80–68993

© 1980 United Technologies
Photographs © 1980 Alfred Eisenstaedt

Published in 1981 by Harry N. Abrams, Incorporated, New
York.

Illustrations printed by Sidney Rapoport in the Stonetone®
process on 100 lbs. Northwest Quintessence Dull supplied by
Allan & Gray Corporation. End papers printed by Sidney
Rapoport on Curtis 100 lbs. Delmarva Text. Text sections
printed by Rae Publishing Company on Curtis 100 lbs.
Delmarva Text. Bound by Publishers Bindery, Inc.
Typeset in Monophoto Modern No. 7 by Balding & Mansell

*We acknowledge with gratitude the assistance received in the
production of this volume from :*

The Federal Republic of Germany
The German Democratic Republic
The City of Berlin (West)
Kempinski Hotels
Lufthansa Airlines
Mrs. Karin Davison
Mrs. Ingeborg von Zitzewitz

Printed and bound in the United States.

Klaus Honnef and Joshua Taylor have limited themselves to a brief word of introduction to this book. These authors share the view that Alfred Eisenstaedt's art should be allowed to speak for itself. In similar vein I would merely like to add that United Technologies is proud to have shared in this project. We hope that this book will further strengthen the friendly relations between Germany and the United States.

Harry J. Gray
Chairman and Chief Executive Officer
United Technologies Corporation

A photograph from the past often has an unsettling way of disrupting our sense of historical time. So quaint and long ago, we think, and yet so undeniably present. The directly encountered images of faces and events, ignoring the intervening years, share experiences with us in a temporal *no man's land*.

Not all photographs from the past, of course, provoke this experience. They may belong to passing events, meaningful only by virtue of their context. Or they may be so consciously artful that they never had a life beyond the mind of the artist. Then there are photographs that are only effigies, records of the external appearance of things, which make everything seem remote and quaint. The photograph that defies time is a special breed. It is both of and outside its epoch, rooted in the life of its time yet aloof to historical transiency.

No better examples of this provocative phenomenon can be found than Alfred Eisenstaedt's photographs taken in Berlin some fifty years ago. Given the mythology built up around life in the German capital of those years, it would be easy to read them only as documents of the time. There are famous faces and well-known sites, as well as recorded incidents that might be taken as symbolic in the light of later happenings. To recognize a youthful likeness of a future star creates a momentary thrill, an unexpected sense of intimacy. But Eisenstaedt's images linger in the mind long after the pleasure of recognition or speculations about historical symbols.

For the most part, Eisenstaedt's compositions are relatively simple and uncomplicated. They concentrate, without any distracting irrelevancies, on the matter at hand. With extraordinary single-mindedness, each image is presented as a total, single visual event.

Although this simplicity shows consummate craft, it does not fully explain why the image, once isolated, has the effect it has. While his sense of visual aplomb creates the necessary conditions, Eisenstaedt's quality comes not simply from a mastery of composition. He has the extraordinary faculty of knowing what he is looking at. Most people, of course, suppose that they know what they see, but knowing is more than just assessing the evident facts. To know is to see with meaning, to recognize that the image encloses within itself a greater significance than meets the eye. Just what that meaning is remains for others to speculate about; but the knowing comes only in the seeing. Each of

Eisenstaedt's deceptively simple images presents itself as an essential statement distilled from an otherwise diffuse or commonplace situation. Looked at years later, the images convincingly retain their essential truth, even though the viewer may be ignorant of the specific situation from which they were drawn.

As a young photographer in Berlin in the 1920s and 1930s, Eisenstaedt was very much a part of the place from which he drew his material. His was not an outsider's eye, looking for novelty, but the eye of one who belonged. His selection of material and how he viewed it was in no sense random; they were informed by the cultural atmosphere in which he lived. When he focused on a face or a cityscape it was inevitably within a social as well as a perceptual context. His respect for the great personalities of his time was consistent with the period's concern with heroes. The very poise of his compositions reflects the individual consciousness of his subjects, a kind of visual decorum suitable to an age in which each act – whether socially proper or improper – was accorded its ideological due. Only in an age of significance could one be concerned with meaninglessness, and sometimes Eisenstaedt's cool vision reflects this as well.

To speak of Eisenstaedt's "visual knowing," then, is to refer both to the man and to the cultural environment in which he worked. His people are never simply types, because they are imbedded in their contemporary mythology. We accept them as universally human, imbedded as we are in our own.

But what does it mean to go back, to jump over the span of years that separates this intensely identified period from the present? What is the effect of contrasting the past-present with the present itself? The results provoke a range of thoughts, not just about historical change but about our own perceptions of value, our visions both inside and out of a transient world.

Eisenstaedt's exploration of his past provides a revealing essay on the nature of man.

Joshua C. Taylor, Director
National Collection of Fine Arts,
Smithsonian Institution
Washington, D.C.

When Alfred Eisenstaedt emigrated from Germany, the Nazis were beginning to establish themselves. By the time he returned, the two republics, the inheritance of Hitler's heirs, had been in existence for thirty years.

During the intervening decades, when Germany changed more fundamentally than at any other time in her eventful history, Eisenstaedt made a new home for himself in the United States. In the meantime his homeland declined in both influence and area, was divided once more, this time definitively – and was also saddled with guilt as no country had been previously.

What took this eminent photographer back home? Outwardly a commission, but I suspect in his heart he was haunted by recollections and that he wanted to take this chance to check his memories. He wanted to compare the reality of modern Germany with the images in his mind and with the photographic images which had made those memories permanent and at the same time given a shadowy permanence to fragments of Germany's past. The photographer's eternal, vain dream is to arrest time and make it stand still.

It was inevitable that in a comparison of this kind he had to bridge the intervening years, but here lay the particular charm of the undertaking: to rediscover those fruitful years of fundamental change since, in the comparison of past and present, which itself soon becomes past, he recognized that they were free from the stifling influence of the present.

If one compares Alfred Eisenstaedt's most recent pictures of the two Germanies with those he took in the '20s and '30s, change and continuity are equally evident. The pictures of the young German photojournalist form a framework within which the pictures of the older American photographer find their proper place. Thus his separate photographic statements bridge the eddying vacuum of the intervening years. Present and past are telescoped so the familiar appears strange and the strange familiar.

The enigmatic quality of Eisenstaedt's pictures contrasts with images on the same subject which we are fed daily by films, television and the press – and show their one-dimensionality. They are undeniably subjective pictures. The new pictures are photographic memories, full of history. For all the photographer's candor, his consciousness of time is evident in every picture.

In Eisenstaedt's work it is not the subject matter but the concept which is

important. Thus Marlene Dietrich personifies the Germany of the Weimar Republic. Pöseldorf, the chic Hamburg neighborhood, symbolizes West Germany; and the goose-stepping soldiers, East Germany. A particular choice of models, objects and situations establishes far-reaching associations, while familiar associations are destroyed and new ones created. Taken together the photographs form the subjective vision of an eminent photographer who is able to see the particular in the general through his ability to present it in a particular visual way.

If one were to categorize his photographs stylistically, one would praise them as outstanding examples of photography of the "decisive moment" and compare Eisenstaedt with Cartier-Bresson, Kertesz and Salomon. But I prefer to use a literary concept: Lessing's concept of the *fertile moment*.

The *fertile moment* is not evident in Eisenstaedt's photographs at first glance. The picture showing a wreath in memory of Beethoven in the house where the composer was born in Bonn seems insignificant in itself, but it is made significant by the Nazi emblem displayed on the ribbon. The picture showing a sculpture of towering legs and the male genitals strikes one at first as mere exhibitionism; but it is brought into relief by being placed in front of a boring row of houses. The picture of three happy fathers with their sons is merely sentimental at first glance. The fact that the fathers are moving in rhythm as if wired together imbues it with the spirit of the age. In Eisenstaedt's photographs the essential point is usually hidden behind suggestion.

Unquestionably, Eisenstaedt's Germany is our Germany. The photographs open our eyes. In this respect his visit provided a fertile moment, not only for the photographer himself, but also for us, the people of both German Republics – and for that Germany which now only exists in our memories.

Klaus Honnef
Head of Department for Exchange Exhibitions
Rheinische Landesmuseum
Bonn

After long absence, some people come home to die, others to see how they have lived. Alfred Eisenstaedt, very much alive at eighty, returned to Germany in September 1979 after forty-four years away. Armed with his curiosity, his memory, and his art, he would try to document present-day Germany as he had documented Germany in the years 1928–1935.

He would do what he has done for fifty-two years: go, have a look around, take pictures. He would produce images, impressions, not statements. If they represented social history, it was only because he photographed what he saw.

At the same time, this assignment would have emotional impact for him. The country was, after all, his home from 1898, when he was born in Dirschau, West Prussia, until 1935, when he left Berlin for the United States.

Five years ago, when I first asked Alfred about his long absence, he said simply, "Nobody ever sent me there." His reply conjured the image of the photojournalist, bags always packed for the next assignment. He had, indeed, lived this way for half a century: first as a photographer in Germany, whose assignments were to St. Moritz and Ethiopia and Rio de Janeiro and political conferences throughout Europe; and later for *Life*, where there were some 2,000 assignments in forty years. But there was something too ingenuous in his claim that he was only waiting to be "sent" to Germany. Surely a trip home would be more than just another job.

I suggested a book on which we might someday collaborate, and a few weeks later he called to tell me he had been rummaging through hundreds of old pictures taken during his years in Germany. While I had merely been positing a trip, he had already begun it. Confronting the past, he had become excited about contemporary Germany – especially if we could juxtapose images from the two eras.

I promised to go through the old pictures with him in his office, a classic in jumbled humility in the Time-Life Building. When I got there, I found him among stacks of boxes already labeled "Germany" and – comically – "Vitiello." We sat together for hours, surrounded by some of the great Eisenstaedt photos – of John Kennedy, Marilyn Monroe, Sophia Loren. Glass plates were passed gingerly from hand to hand while we sorted, rejected, and

pruned the photos worthy of consideration. We were confident we had half a book – for the second half we would have to wait.

Four years later, when United Technologies proposed to do the book, we felt alternately complacent and nonplussed. Perhaps I should say I felt complacent, and Eisenstaedt felt nonplussed. I imagined the hard work had been done; he knew it hadn't.

* * * * *

In Berlin, the stateliness of memory has been overtaken by ghosts. Once-elegant streets such as Leipziger Strasse and Potsdamer Strasse have been severed by the Wall. Repeatedly, looking out at its graffiti and its mined fields, Eisenstaedt would say, *I don't understand this Wall business.*

Time has been impartial. Outside our hotel window was the façade of a burnt-out synagogue. A couple of miles away was the bombed-out remnant of the Anhalter Bahnhof, from which seventeen-year-old Eisenstaedt had left Berlin as a German soldier in World War I. It was the same station in which he had photographed an old woman shrouded in steam. (This photo, the second he ever sold, invited skepticism at the company where he was a belt and button salesman. *Are you still doing that – what do you call it?* his fellow employees would ask.)

Returning to photograph the station now, he was distressed not by the memory but by the paucity of light. *If I shoot it now*, he said, *it will be all wrong. Totally flat. Nothing but a "point picture."*

We left the station and returned later, only to find the light was still wrong – a personal affront to the photographer. Undaunted, he walked around the ruin until he found the exact spot for photographing it and marked the place with a dented beer can. The next day the light was right, the beer can was still in place, and the picture could be taken.

Our trip to Germany was compounded of many such moments in which Eisenstaedt distilled memory into an image. He found, and confronted, whatever similarities existed between past and present: people he had

photographed before, streets he had walked down, the quality of light on a cobblestone street.

From 1906 to 1935, Eisenstaedt had lived in three apartments – all in the Wilmersdorf section of Berlin. On Helmstedter Strasse he had become a photographer, developing his own pictures in the tub while the family waited to use the bathroom. From there he had left on his first professional assignment – to Stockholm in 1929 for the Nobel Prize presentation to Thomas Mann. In that same apartment, five years later, he had answered the door to men with swastikas (who, as it turned out, only wanted copies of themselves posing with Joseph Goebbels).

The house at Helmstedter Strasse was not standing when we arrived in September 1979. Instead, there was a stucco house, modeled awkwardly after its predecessor.

Gone too was an earlier residence at Haberland Strasse. The street itself seemed to have disappeared, but memory and perseverance led us to the renamed Treuchtlinger Strasse. After patient scrutiny, we found a plaque almost opposite Eisenstaedt's former home that read:

Hier wohnte
In dem früheren zerstörten Hause
von 1918 bis 1933 Albert Einstein . . .

Einstein had been Eisenstaedt's neighbor. Now his house too was gone.

Despite the unfamiliarity of these blocks, our walks through Wilmersdorf provided Eisenstaedt's memory with a context. Seeing, and comparing past and present, he reminisced. Finding his way to Viktoria-Luise-Platz, he located the spot where he had played marbles as a child and the bench where he had read. Nearby, he had photographed his mother. It had been one of his earliest photographs.

Walking through his old neighborhood now, he took few pictures until he came upon his old school, formerly the Hohenzollern Gymnasium, now the Riesengebirgs-Oberschule. (*What kind of name is Riesengebirgs-Oberschule?* he asked.) He marveled that he had found it by retracing his steps from sixty-five years ago. He marveled especially at the students: jaunty, long-haired children in jeans and running shoes who might have been transported intact from an

American schoolyard. Where, he wondered, were the dutiful, formal children of his era? When his math teacher had entered the room, everyone had stood at attention. Now the principal wore a short-sleeved shirt over his pants and was as breezy as the students.

When Eisenstaedt photographed the children in the schoolyard, they wanted to know why he was taking their picture. A child of his generation probably would not have asked why.

There is nothing of Helmstedter Strasse or of Viktoria-Luise-Platz in these pages, for the book is not an album or even a memoir. It is, instead, a volume of photographs that grow from one man's insight. It is a record of a way of seeing rather than a document of history's accidents.

* * * * *

The great photographer must be part painter, part archaeologist. He must compose his pictures so that every detail is necessary and no detail is excessive. He must also appreciate chance.

Eisenstaedt learned to see as a painter sees by studying the old masters – Rembrandt in particular – at the Kaiser Friedrich Museum in Berlin. He learned from them that *light only falls in one place*, and that life can be shaped to the artist's perception.

Composition was not essential to his early news assignments, but it mattered to Eisenstaedt. The photograph of Emil Jannings' wife and daughter playing ping-pong on the lawn at Wolfgangsee is a photograph we admire half a century later.

We also admire the photograph which not merely piques our curiosity with its eerie street sweepers and their cache of bodies, but for their *danse macabre*. The photograph was, in fact, taken on the set of Rainer Werner Fassbinder's *Berlin Alexanderplatz*. It resembles no other movie still I have seen.

Perhaps Eisenstaedt was lucky to find a Dalmatian peering out of the back window of a small Porsche as we wandered through Hamburg's chic Pöseldorf section. What matters is that he saw it and kept the dog's attention by making

a noise like a small explosion against the roof of his mouth. *If it had been a toy poodle, it wouldn't have made a picture*, he says. *It had to fill the whole frame.*

By luck or design, the photographer must *find* his subject. The woman standing in the rain gazing up at a crucifix is one kind of discovery. The East German soldiers being photographed by their lieutenant is another. (*They never do that normally*, our German driver said of the picture-taking ceremony. The photographer's job is to spot what *they never do normally*.)

Another piece of luck had nothing to do with design or memory, but has historic interest for this book. It regards some of the photographs on these pages which we found on a chance visit to the offices of Berlin's *BZ*. At another time, Eisenstaedt might have been impressed by his prominence in the newspaper's archives. Now, as his remarkable memory failed him, he said only, *I took these pictures?*

He had certainly taken pictures of Max Schmeling and Leni Riefenstahl – the one in 1931, the other in 1928. Foraging through his old photographs, time and again he had alluded to these two Germans, both still vigorous half a century after he had first photographed them. If only he could meet them again. *Now this would be something*, he said, *the same photographer and the same people fifty years later.*

In 1928 Eisenstaedt had photographed Riefenstahl with Marlene Dietrich and Anna May Wong at the Reimann Arts School ball in Berlin. She was then an actress, but later became a filmmaker and director of two documentary classics – *Olympiad 1936* and *The Triumph of the Will*. Since her work had the Führer's imprimatur on it, she was discredited for more than twenty years following World War II. Then, within the past decade, she produced three extraordinary books of photography: two on the peoples of Nuba and Kau, a third on coral reefs.

Fifty-two years ago Eisenstaedt had photographed Riefenstahl with an Ermanox box camera, inserting glass plates which he removed from one pocket, then stored in another after shooting. Now he used a Leica.

* * * * *

Before coming to her Munich apartment on this day in March 1980, he had prepared himself for the meeting by a mental discipline part photographic, part conversational. Remarkably, he had remembered the name of Sepp Allgeier, Riefenstahl's cameraman in the 1930s.

In her apartment, Eisenstaedt repeated Allgeier's name, and Riefenstahl parried with other names, especially those of Americans he might know, such as Jesse Owens. Meanwhile, his conversational gambit relaxed her. He could begin composing his picture. *Please talk to me*, he kept saying as he knelt, snapping her, *tell me how you work.*

She spoke animatedly of her work, her acquaintances, her travels. Then, knowing the words were artifice, she began repeating *Lieber Herr Eisenstaedt, lieber Herr Eisenstaedt.*

When she asked him about himself, he was reticent. Finally, as the session was ending, she said, *You must have photographed me before.*

He nodded.

But not with Hitler?

No, not with Hitler.

But you did photograph me before.

Don't worry, this picture will be much better. This is a glamour picture.

That's good. I didn't like the other one very much. She smiled, acknowledging that she recalled their first meeting more than half a century ago.

As we were leaving the apartment, he said, *In New York, people were always asking me, "Why do you want to photograph Leni Riefenstahl? Wasn't she a Nazi collaborator?"*

He paused for a moment, then said, *What those people in New York don't realize is that I don't see Germany with political eyes. I see pictures.*

* * * * *

The words reflected our month in Germany, during which he had refused to generalize from his experiences. The world already had too many stereotypes; his job was to see what was distinctive. He was impressed by many of those he had photographed: Riefenstahl, Theo Sommer, Günter Grass, Peter

Hofmann, Anne-Sophie Mutter. The young Germans seemed freer, more at ease, than Germans of his generation. There was also greater style than in the past. At the same time, he found traditional values – punctuality, cleanliness, order – with which he was comfortable. But these were impressions, not conclusions.

Germany, which had once been his home, was now strange but not totally alien to him. He had returned and, in returning, confronted something in himself.

On Easter weekend we were preparing to leave for New York when we received word of Max Schmeling's return from Africa. He would be available to be photographed in Hamburg on Tuesday from 8:30 to 8:50 a.m., necessitating an extension of our stay. At first Eisenstaedt wavered, fretting about schedules to meet and films to be developed. Then, thoughtfully, he said, *If I don't do it, I'll regret it all the rest of my life.*

For the same reason, he had agreed to come to Germany after forty-four years.

Gregory A. Vitiello
New York, August 1980

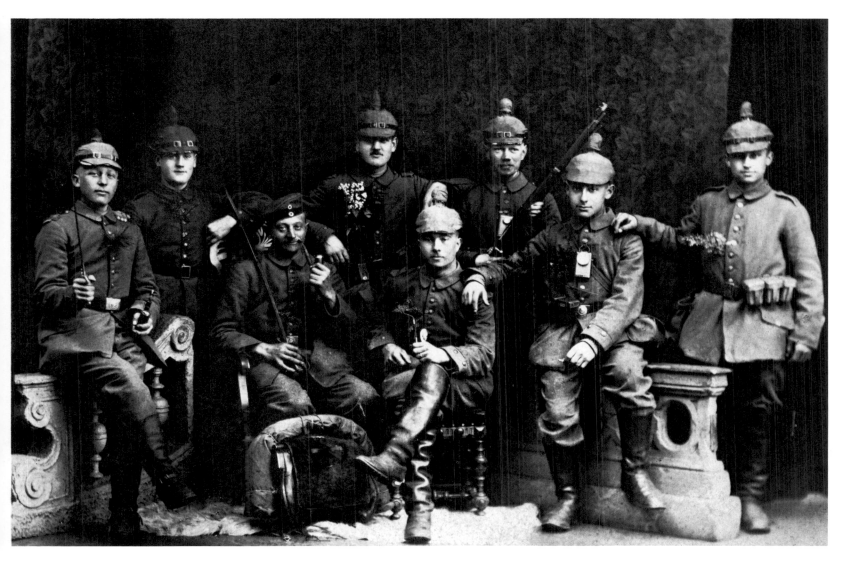

Alfred Eisenstaedt (second from right), 17-year-old private
in the German Army with members of the 55th Field Artillery Regiment
at Naumburg an der Saale, 1916. Eisenstaedt suffered shrapnel wounds
in both legs on April 12, 1918, during an offensive at Dieppe in which only
he and one other cannoneer survived.

I feel myself fortunate in working for more than half a century at a profession I love. This book, perhaps more than any other, reinforces that feeling. Here I am, photographing places and people – sometimes the *same* people – I photographed fifty years ago. I could not have had this extraordinary experience without the help and enthusiasm of several individuals.

First I want to thank Harry Gray of United Technologies Corporation for making the book possible. Ray D'Argenio, also of United Technologies, lent invaluable support.

Greg Vitiello gave me the idea for the book and helped see it through to completion, over many months. I am most grateful to him. Derek Birdsall gave my photographs the extra dimension only a fine designer's eye can provide.

During my travels in Germany I was appreciative of the advice my friend Peter Ramm gave, and of Hans Karpinski's unstinting efforts.

Finally, I am grateful to Gordon Bowman for his sensitive, sensible direction of the entire project.

Alfred Eisenstaedt
New York, August 1980

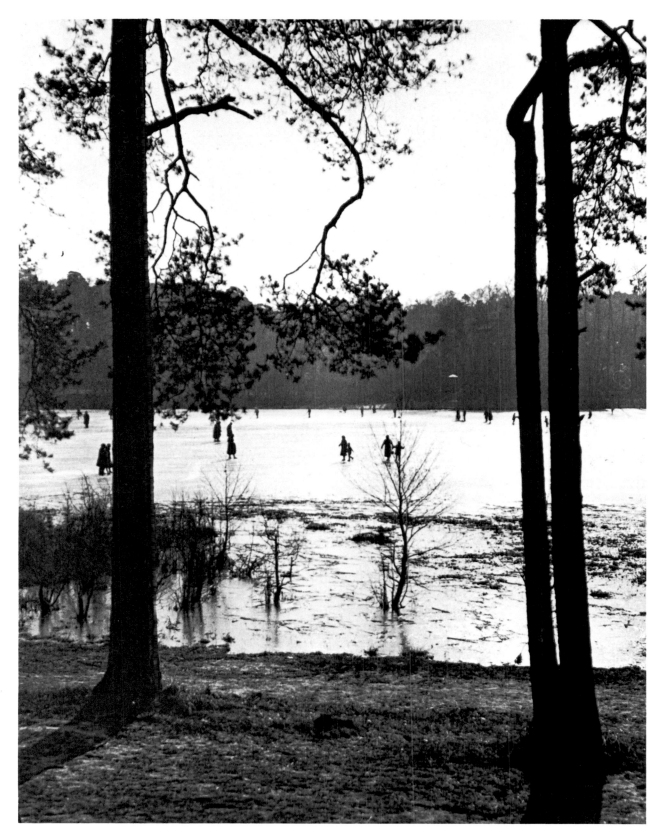

Grunewaldsee, Berlin, 1913.

*This picture was taken with an Eastman No. 3 folding camera. Looking at it,
I don't think you can see any evidence of talent. At that time, I didn't even
know what talent meant.*

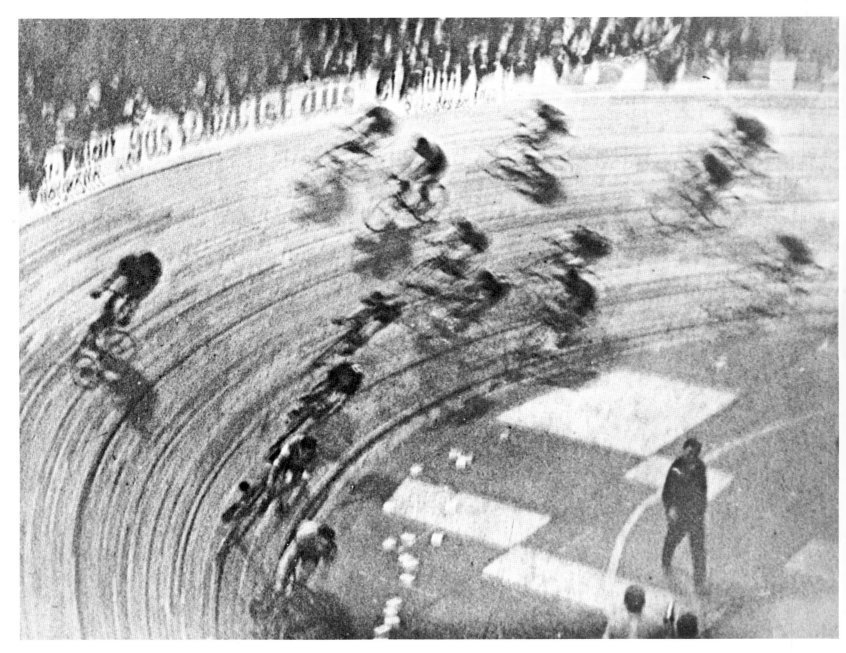

Six-day bicycle race, Sports Palace, Berlin, 1928.

*I took this picture before I became a professional. Since I didn't have an
exposure meter, I guessed at the light. This actually helped the picture, which
would have had less of a sense of motion if it had been sharp.*

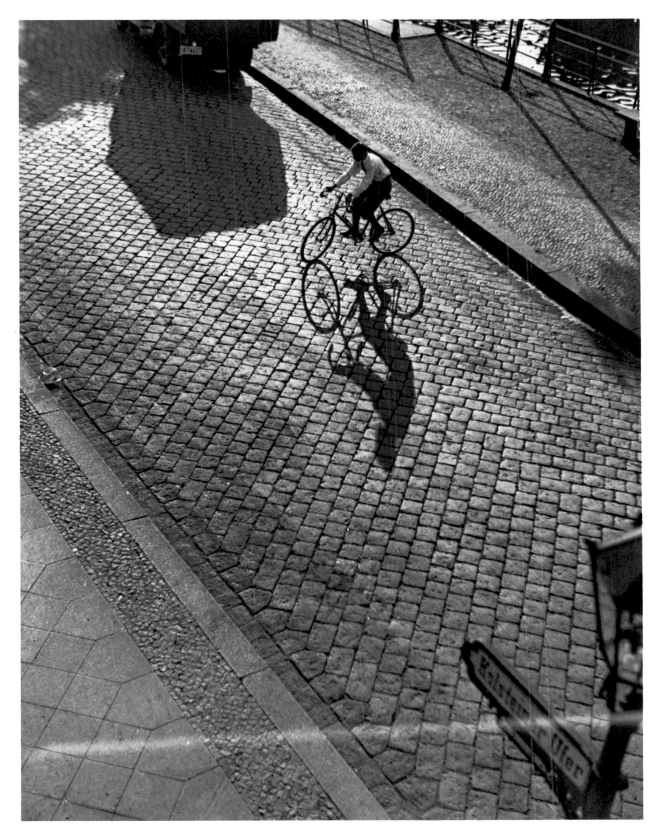

Bicyclist, Holsteiner Ufer, Berlin, 1928.

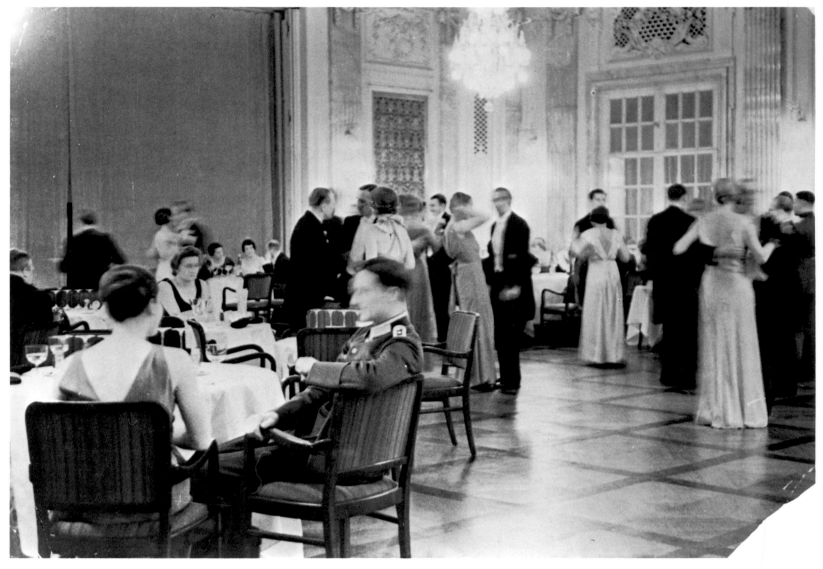

Golfers' Ball, Esplanade Hotel, Berlin, 1929.

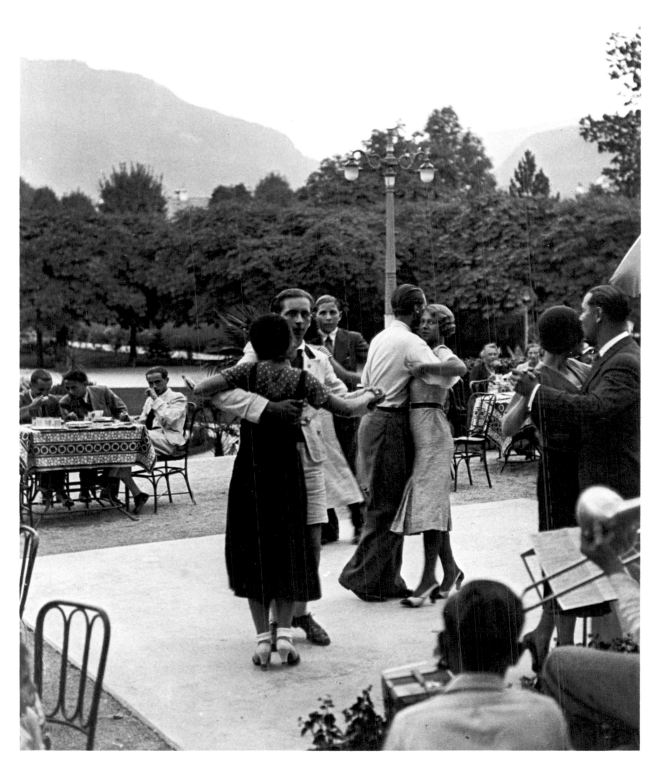

Tea dance, Tegernsee, 1932.

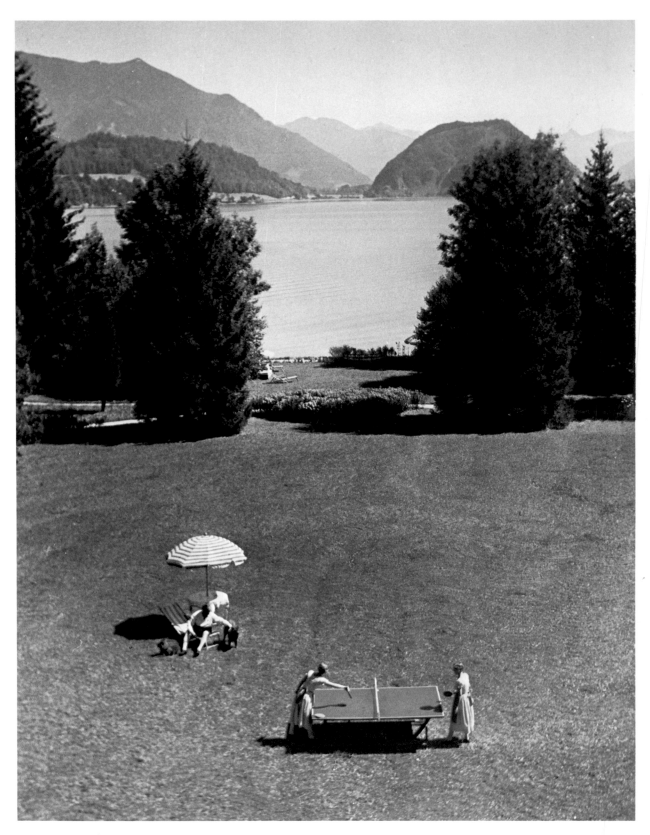

Actor Emil Jannings and family on vacation, Wolfgangsee, Austria, 1932.
His actress wife Gussy Holl and daughter Ruth are in foreground.

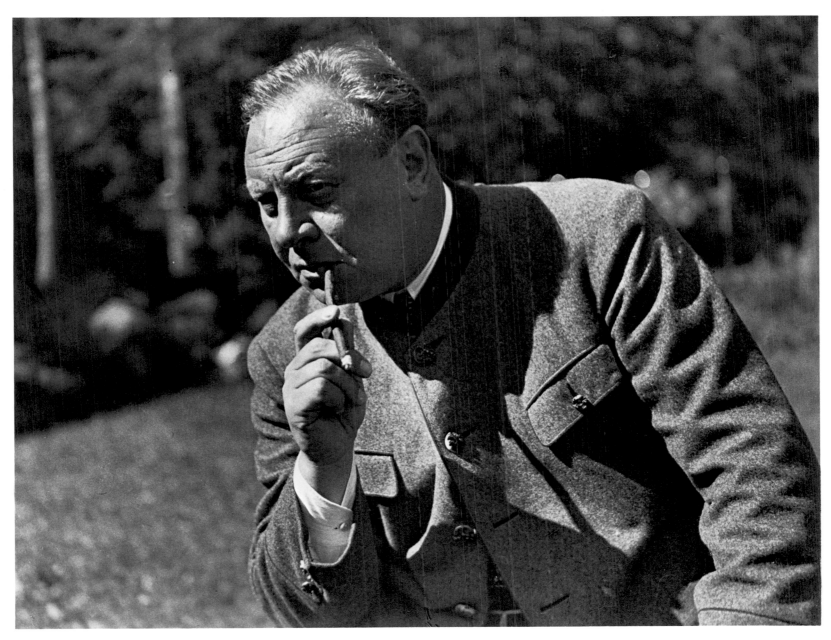

Emil Jannings. Wolfgangsee, 1932.

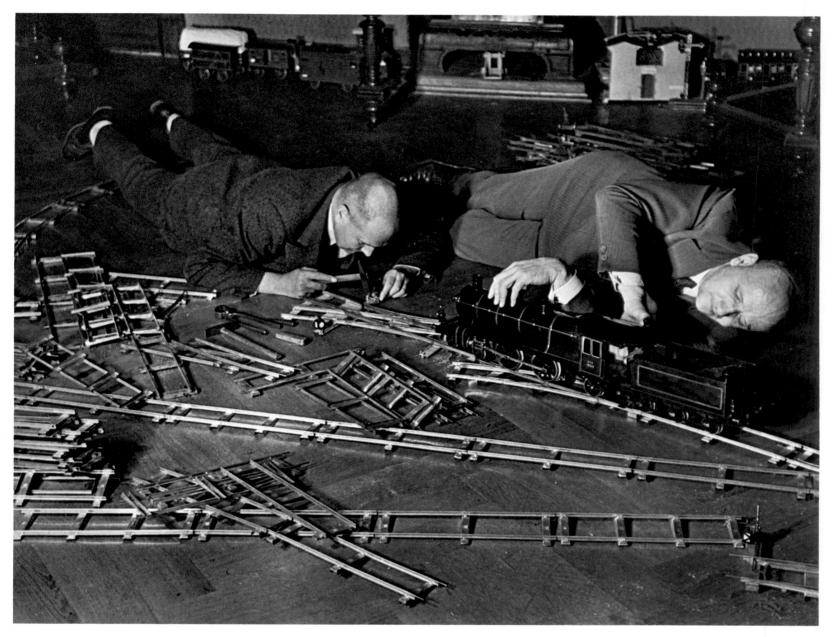

Toy train society, Berlin, 1931.

I laugh every time I see this picture of elderly businessmen in stiff collars winding up toy trains on the floor of their society. Just think – these societies still exist. Only the technology is different.

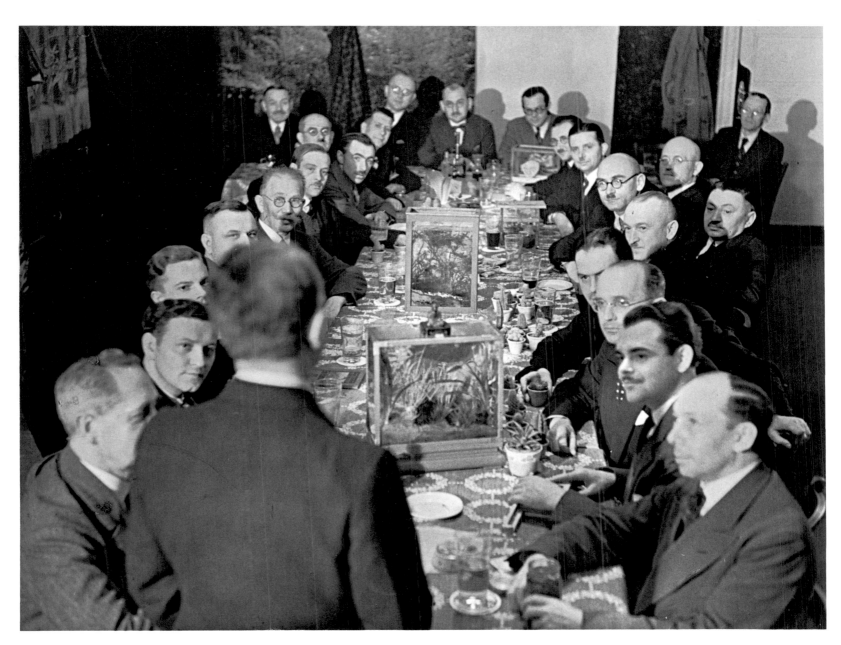

Aquarium society, Berlin, 1931.

What did they talk about at those meetings? Siamese fighting fish and the mating of guppies. Fifty years from now they'll be talking about the same things. It isn't surprising in a way: when I was a boy, everyone I knew had an aquarium. I did as well.

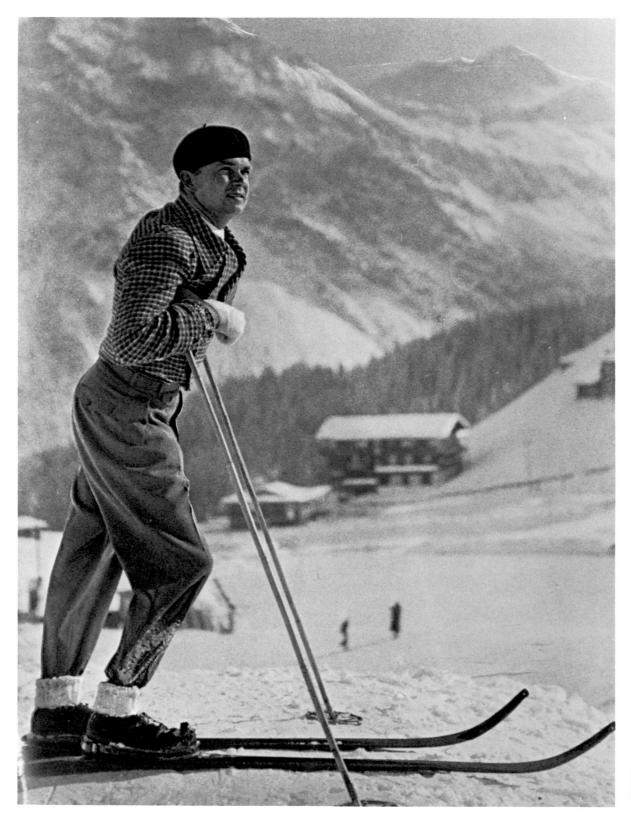

Rudolf Caracciola, Mercedes racing driver, Arosa, Switzerland, 1932.

Luis Trenker, Alpine skier and film actor, Davos, Switzerland, 1932.
Trenker, who formerly appeared in films of Leni Riefenstahl, is frequently
seen today on German television.

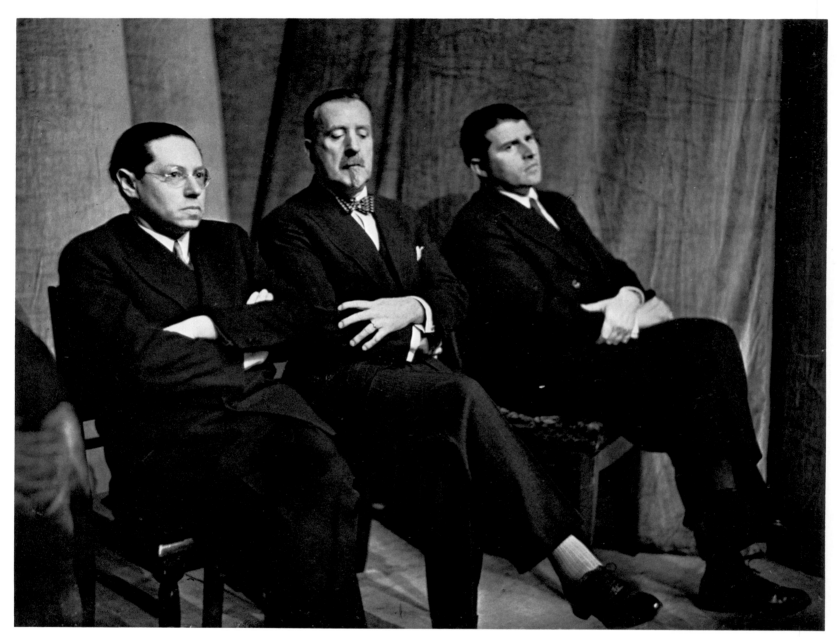

Meeting of Poets Academy, Berlin, 1931. From left: the writers Lion
Feuchtwanger, Heinrich Mann, Carl Zuckmayer.

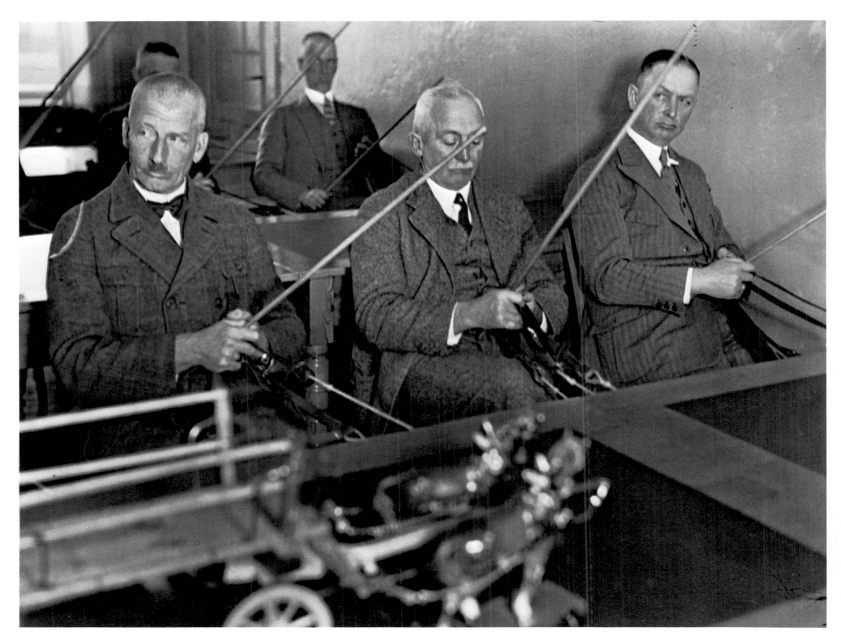

Agricultural school for Prussian Junkers learning to hold reins of
horsedrawn carriages, Neudeck, East Prussia, 1934.

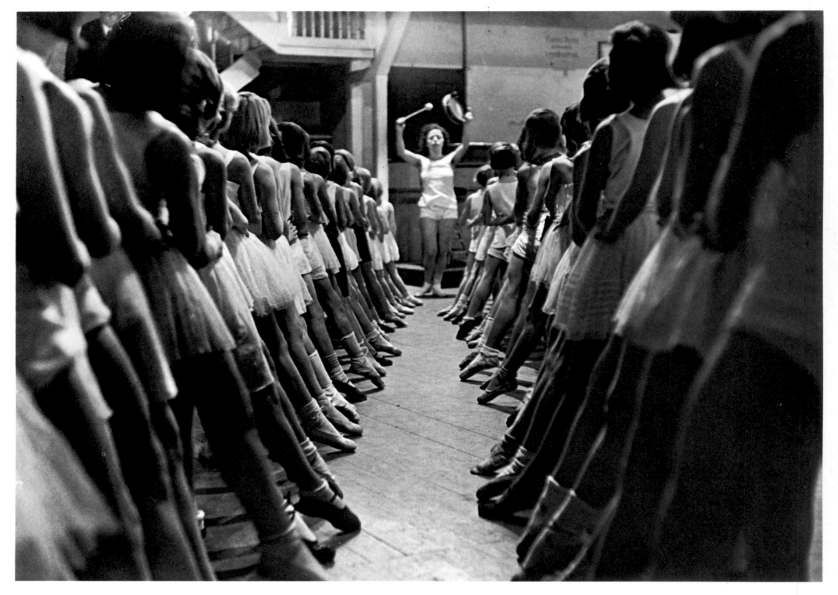

Truempy Ballet School, Berlin, 1931.

*This kind of composition was quite new when I photographed these dancers –
and the midwives on the right – in 1931. It was only later that it became a
cliché.*

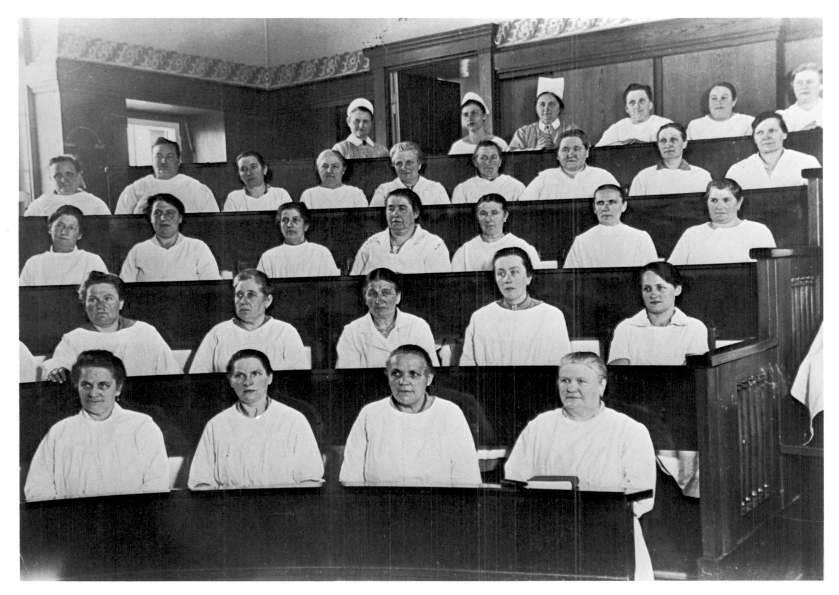

School for midwives being taught new developments in medicine,
Neukölln Hospital, 1931.

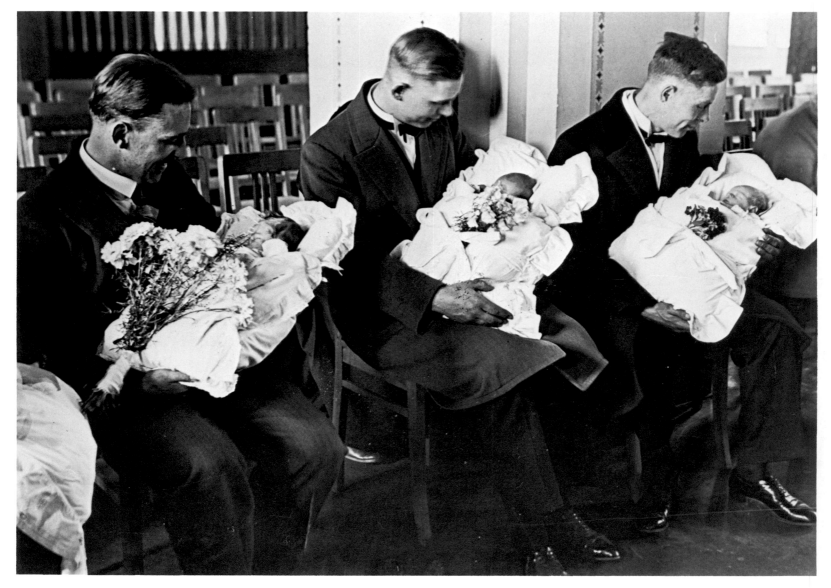

Fathers with new-born babies about to be baptized, Neukölln hospital, 1931.

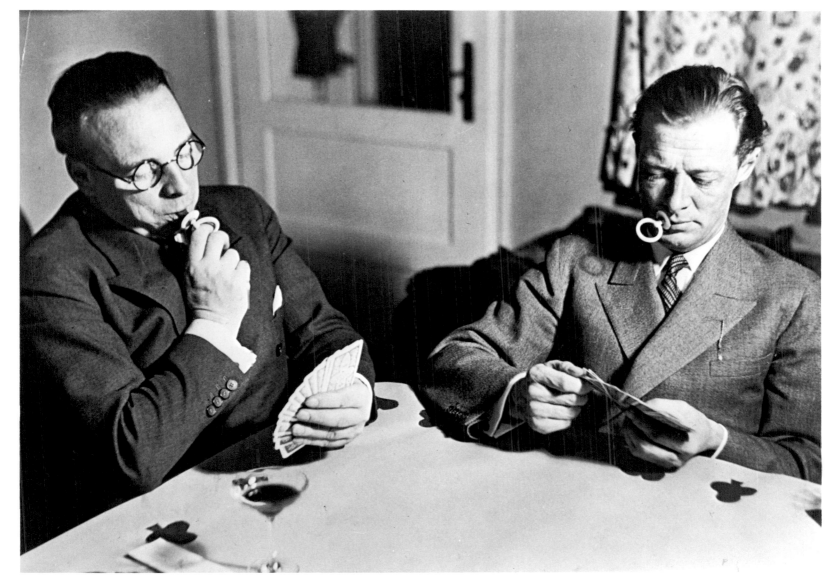

Card players who have given up smoking as a New Year's resolution,
Berlin, 1931.

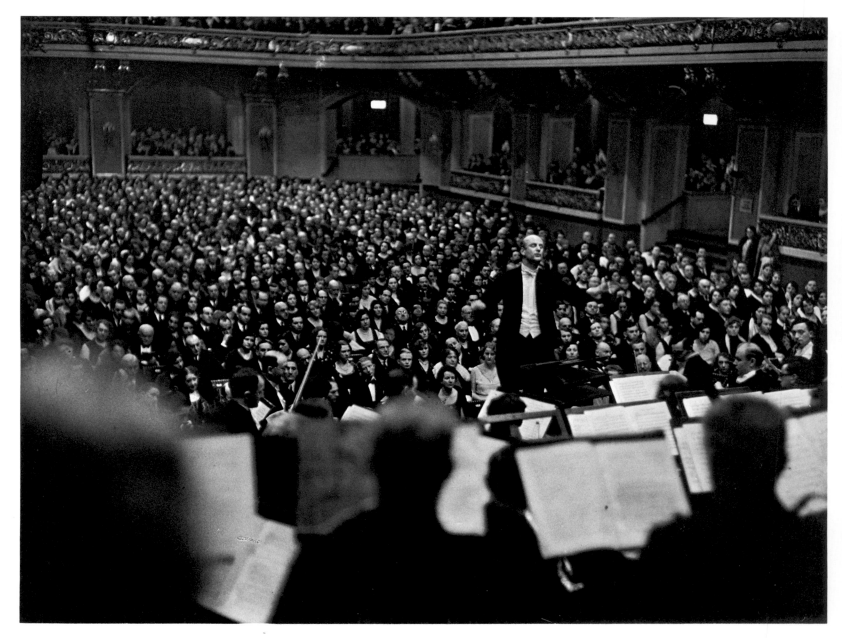

Wilhelm Furtwängler conducting the Berlin Philharmonic in Beethoven's
Fifth Symphony, Berlin, 1932.

*In those days I was the only photographer at many performances. As a result,
I was able to sit right in the orchestra, often behind the second violins. I wasn't
usually assigned to the concerts; I covered them because I was interested.*

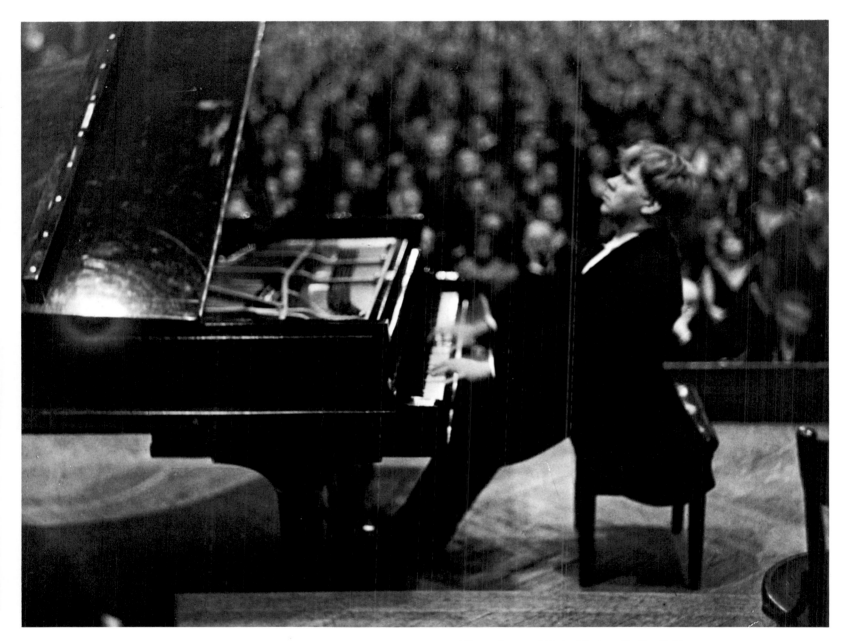

Piano virtuoso Edwin Fischer, Berlin, 1932.

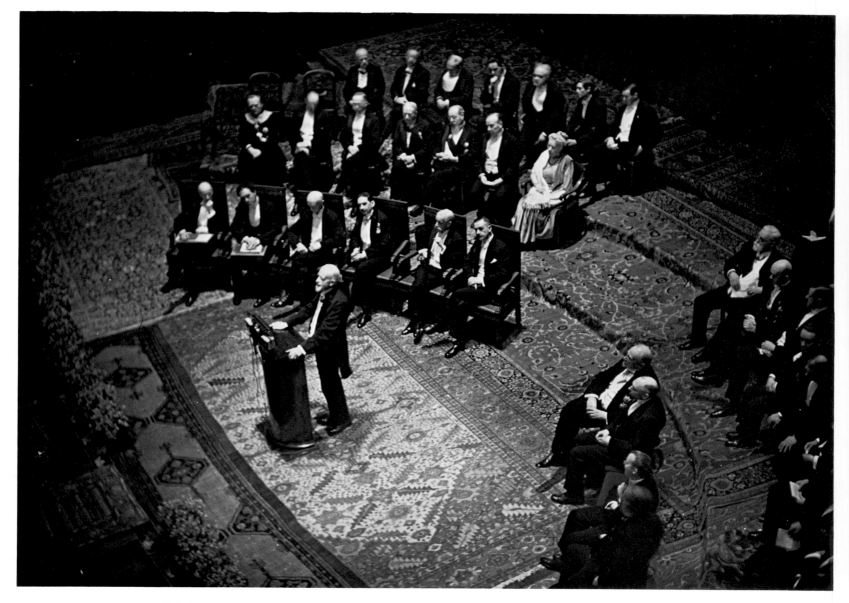

Nobel Prize ceremony, Stockholm, December 9, 1929. Thomas Mann, first
row right, waits to receive the Nobel Prize for Literature, following
introduction by Professor Martin Fredrik Böök. Selma Lagerlöf, another
Nobel laureate for literature, is seated behind Mann.

I had been a professional photographer for six days when Die Funkstunde,
*Berlin's leading radio weekly, sent me to Stockholm. In those days, a
photographer could do anything, because he was virtually the only one
covering an event. I was able to take a close-up of Mann, which I later sent
him a copy of. He responded with a postcard – one of many autographs in
my collection.*

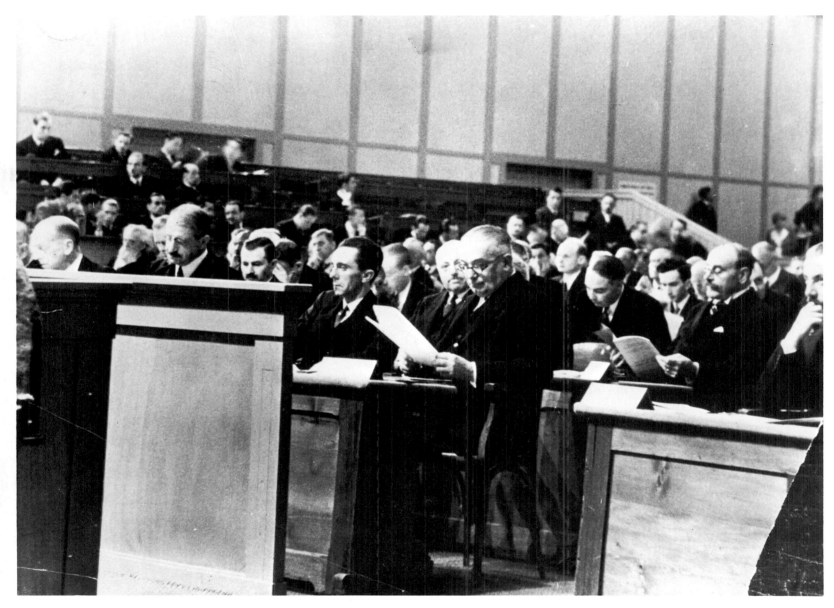

German delegation to 15th League of Nations Assembly, Geneva,
Switzerland. September 1933. From left: Friedrich Gaus, August von
Keller, Minister of Propaganda Joseph Goebbels, Foreign Secretary
Konstantin von Neurath.

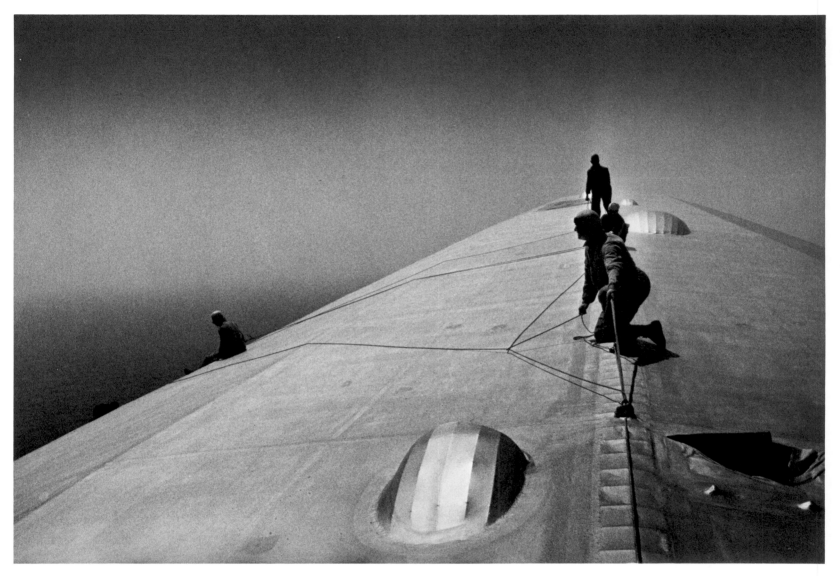

The *Graf Zeppelin* being repaired in mid-air over the South Atlantic
enroute to Rio de Janeiro, 1934.

*I got permission to climb up onto a catwalk used by the crew, open a hatch,
and took this shot in the half-minute or so they allowed me.*

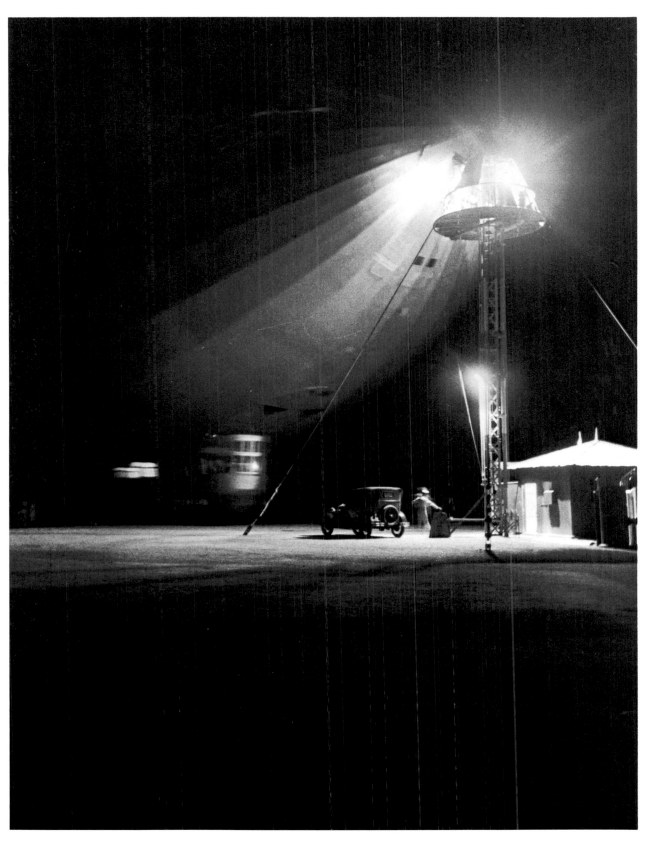

The *Graf Zeppelin* at anchor mast, Recife (Pernambuco), Brazil, 1934.

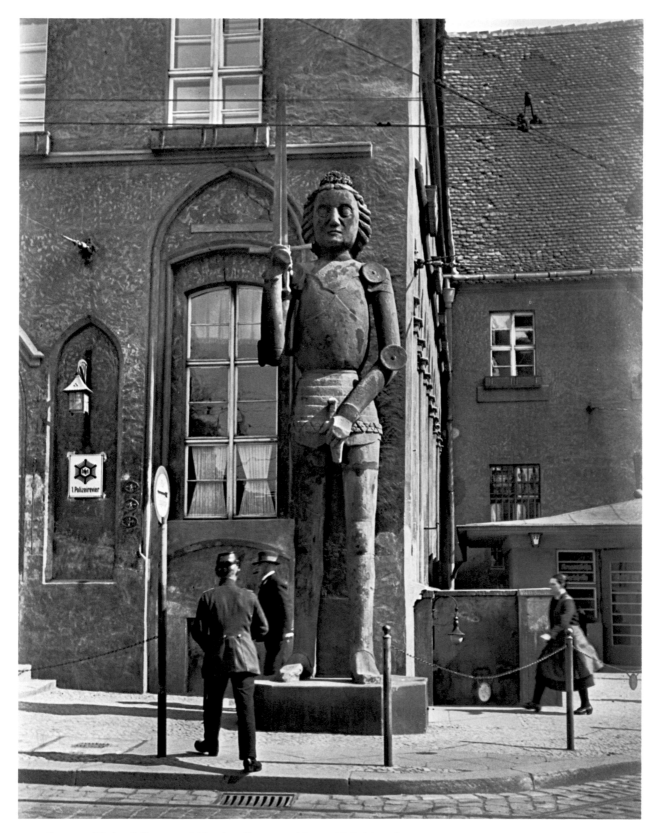

Statue of Roland, Bremen, 1934. A policeman with an old-fashioned
helmet is in the foreground.

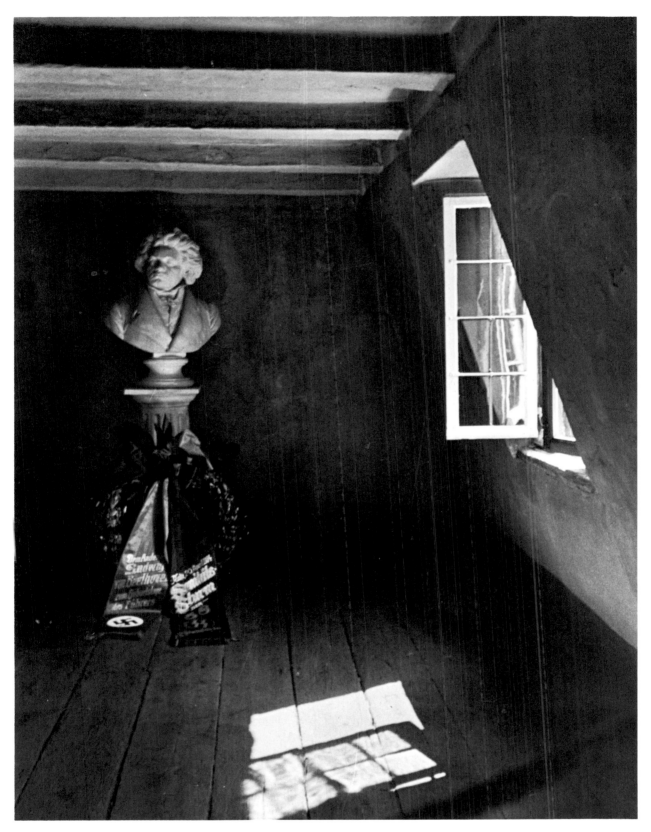

Beethoven's bust, Beethovenhaus, Bonn, 1934.

I was doing a story on the Beethovenhaus when, by sheer coincidence, the Nazis came into the room where Beethoven was born and laid a wreath with a swastika at the base of his bust in honor of the Führer's birthday. After they left, I took the picture both with and without the swastika. I was a little afraid to remove it, but I was willing to take the chance for a good picture. Until now, no one has seen this photo with the swastika.

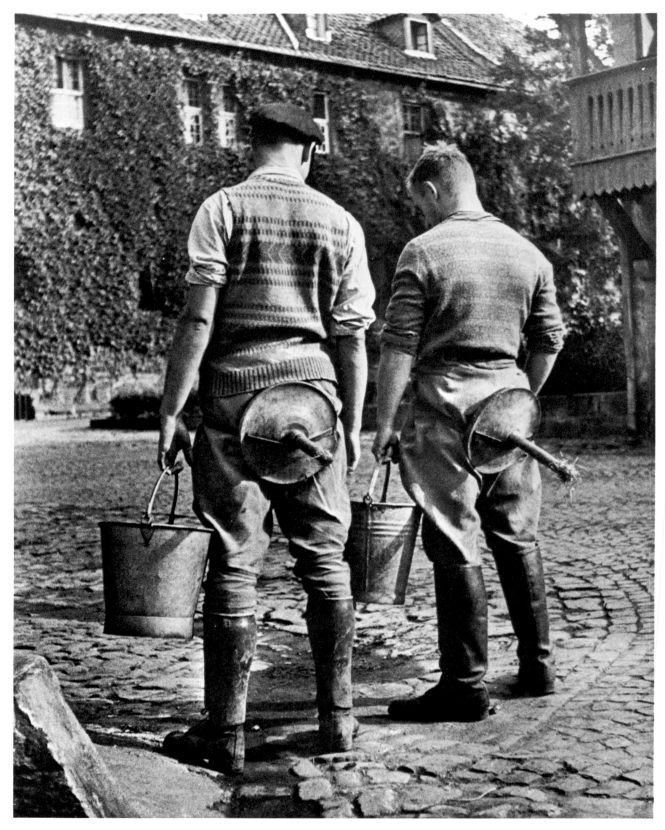

Agricultural students with milking stools, Neudeck, East Prussia, 1934.

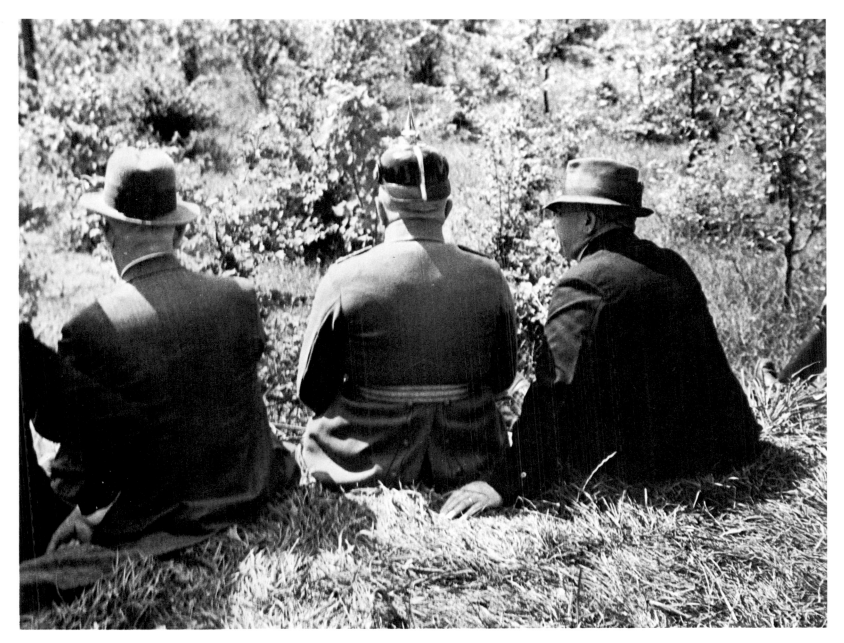

Men attending funeral procession for President Paul von Hindenburg,
Tannenberg, East Prussia, August 1934.

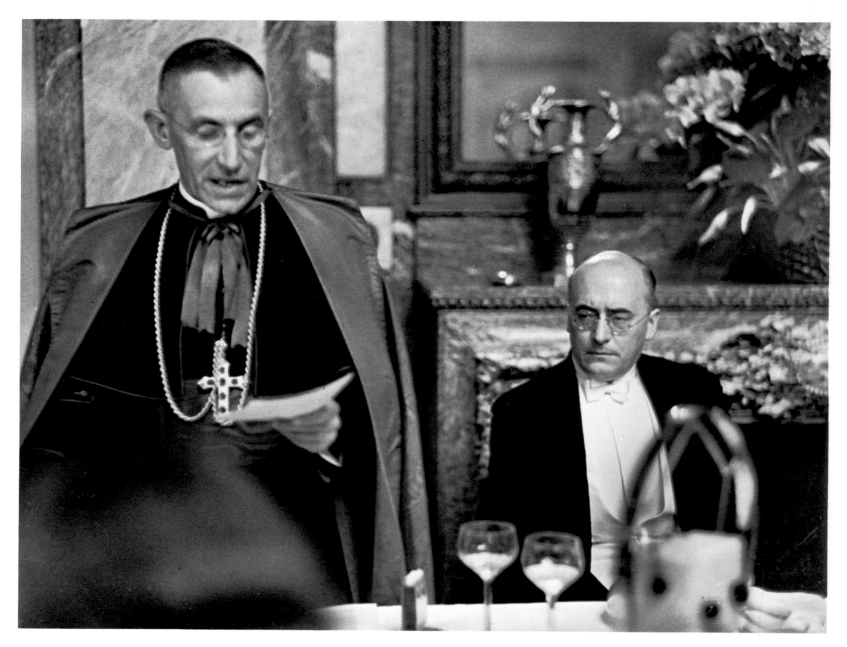

Papal Nuncio Orsenigo, Vatican Representative to Germany, addressing
the Press Ball, Hotel Adlon, Berlin, 1932. On the right is Reichs
Chancellor Heinrich Brüning.

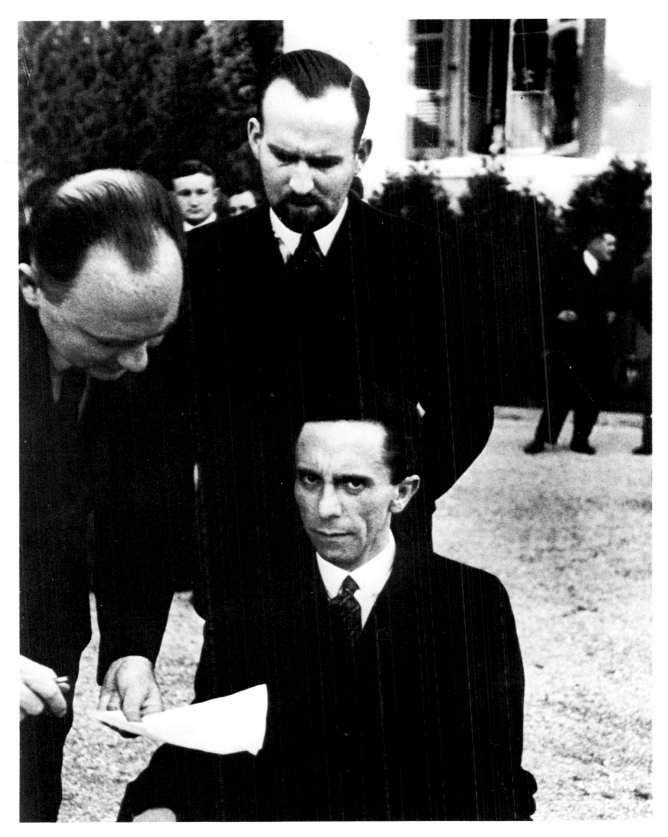

Joseph Goebbels, Minister of Propaganda, with his private secretary and Hitler's interpreter, 15th League of Nations Assembly, Geneva, September 1933.

This picture could be titled From Goebbels with Love. *When I went up to him in the garden of the hotel, he looked at me with hateful eyes and waited for me to wither. But I didn't wither. If I have a camera in my hand, I don't know fear.*

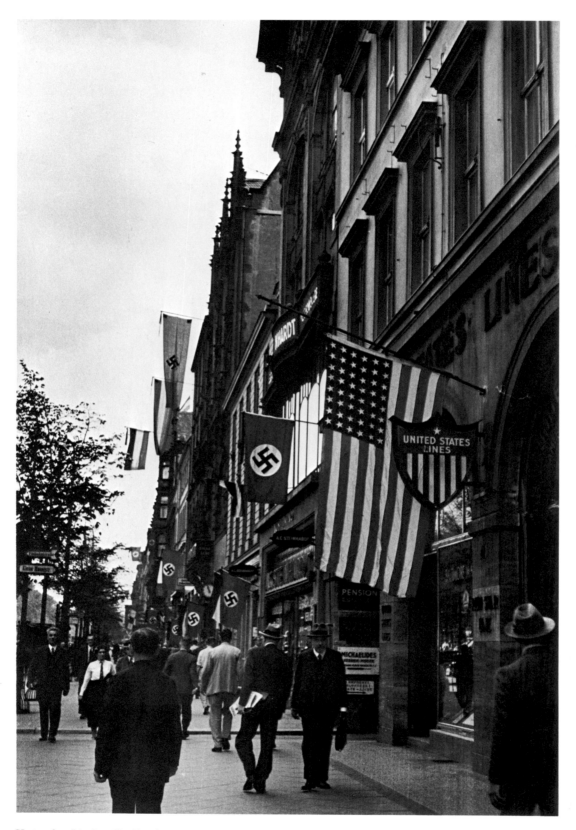

Unter den Linden, Berlin, August 5, 1934. American and German flags
at half mast following Hindenburg's death.

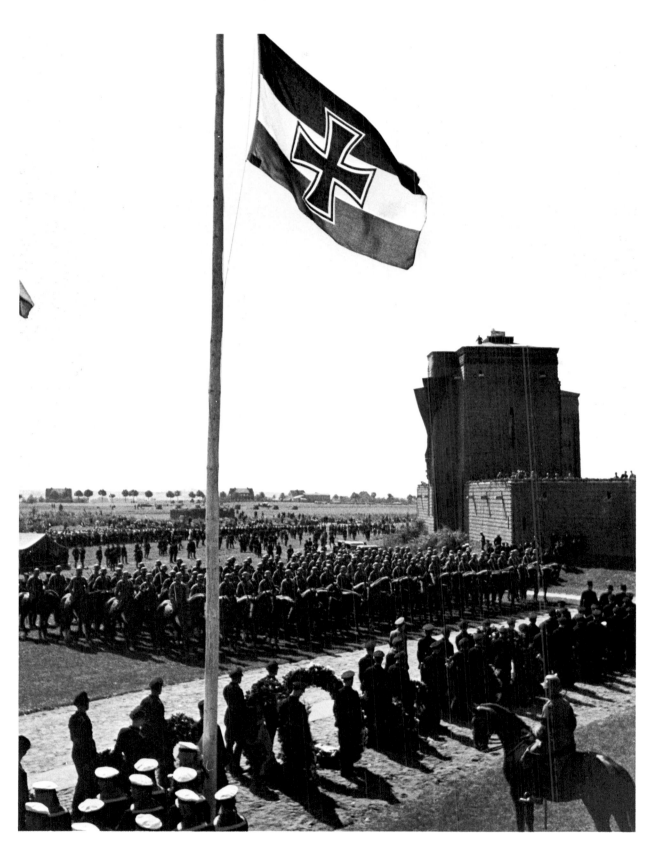

Hindenburg's funeral, Tannenberg, August 1934. War flag of Imperial
Germany is in foreground.

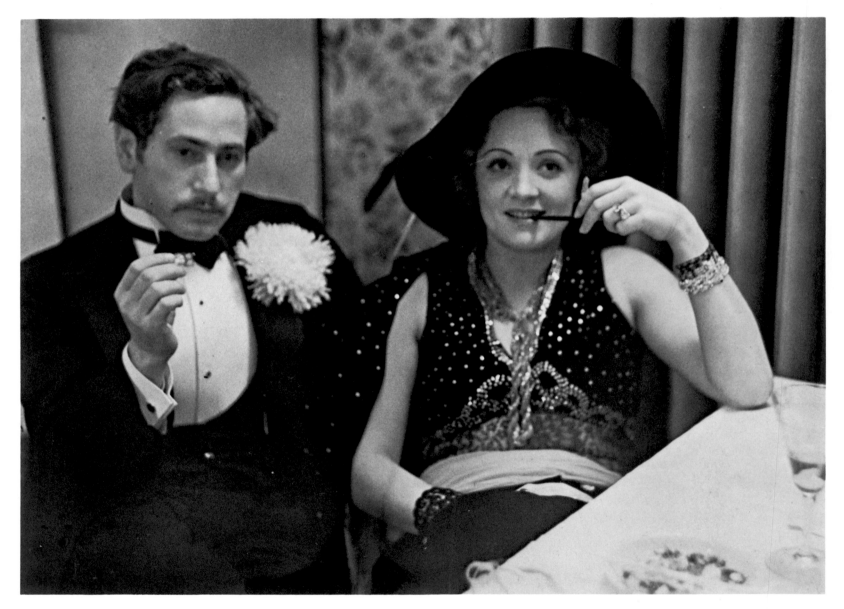

Josef von Sternberg, director of *The Blue Angel*, with his star, Marlene
Dietrich, Reimann Arts School ball, Marmorsaal, Berlin, 1928.

*I came dressed in black tie, armed with the legendary Ermanox camera, 15 to
18 cassettes with glass plates, and a rickety wooden tripod. The pockets of my
coat and trousers were reinforced because of the wear and tear of carrying all
the glass plates in them. To take a photograph, I had to open the shutter with
the help of a cable release, look through the ground glass with a magnifying
glass, close the shutter, remove the ground glass, insert a metal cassette with the
glass plate, take the slide out, and snap the picture. If anyone moved, I had to
do the whole thing all over again.*

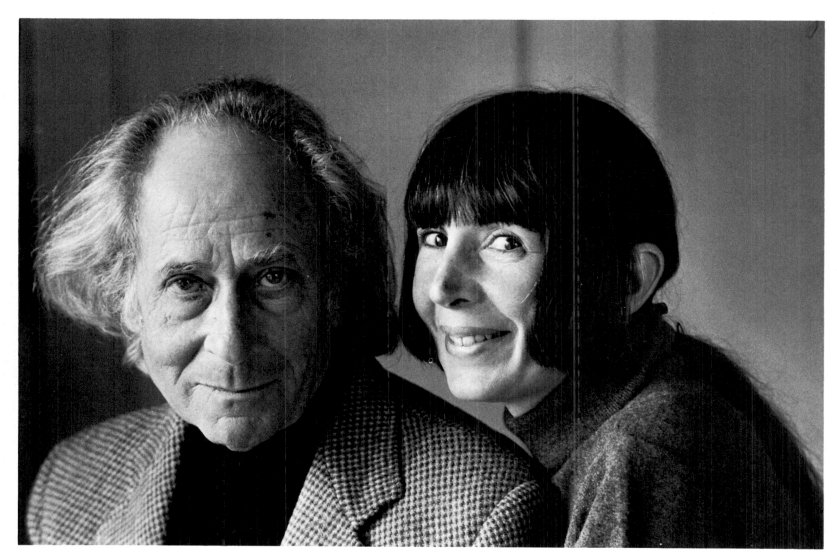

Photographer Eric Schaal with his wife Miriam, Männedorf, March 1980.

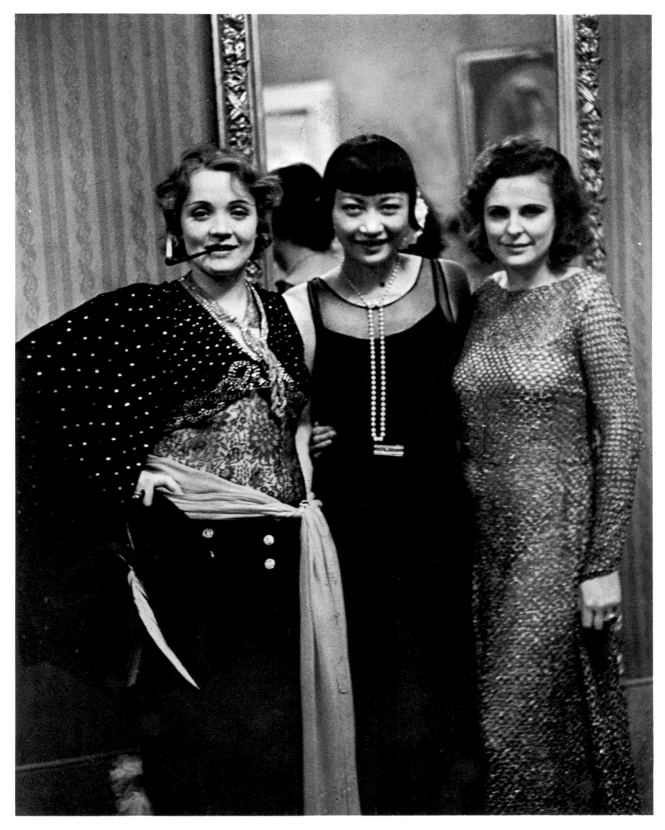

Marlene Dietrich, Anna May Wong, Leni Riefenstahl, Reimann Arts
School ball, Marmorsaal, Berlin, 1928.

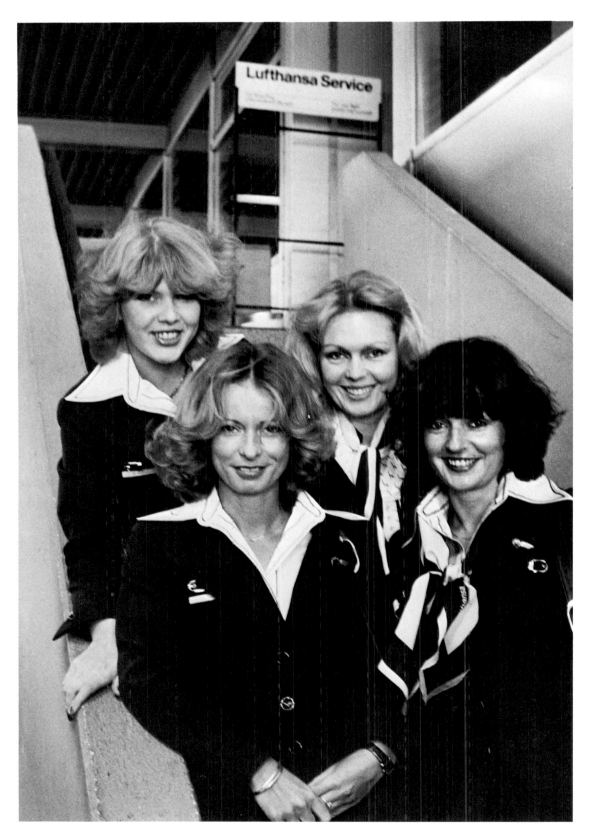

Lufthansa stewardesses, Hamburg airport, September 1979.

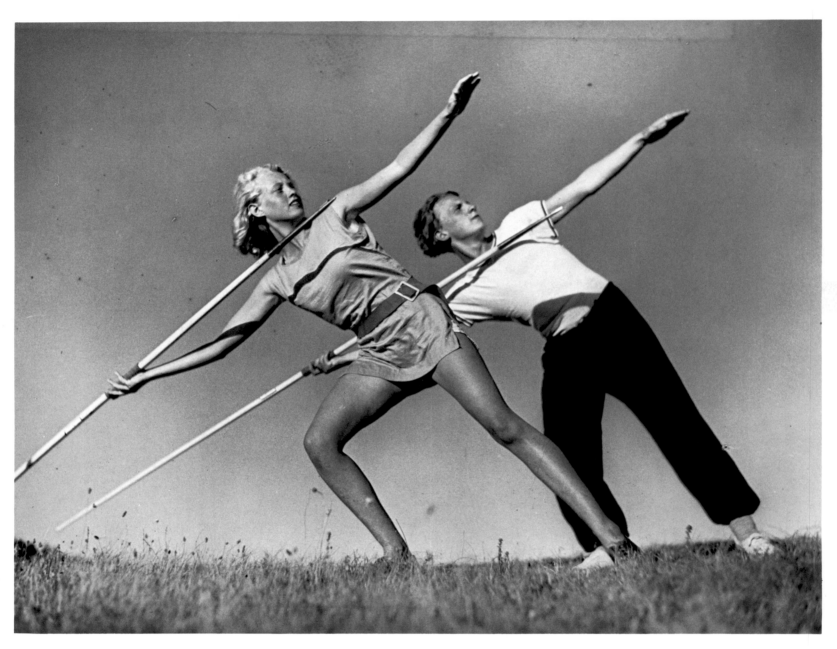

Athletics teachers, Island of Hiddensee, 1931.

This is how German youth looked in 1931.

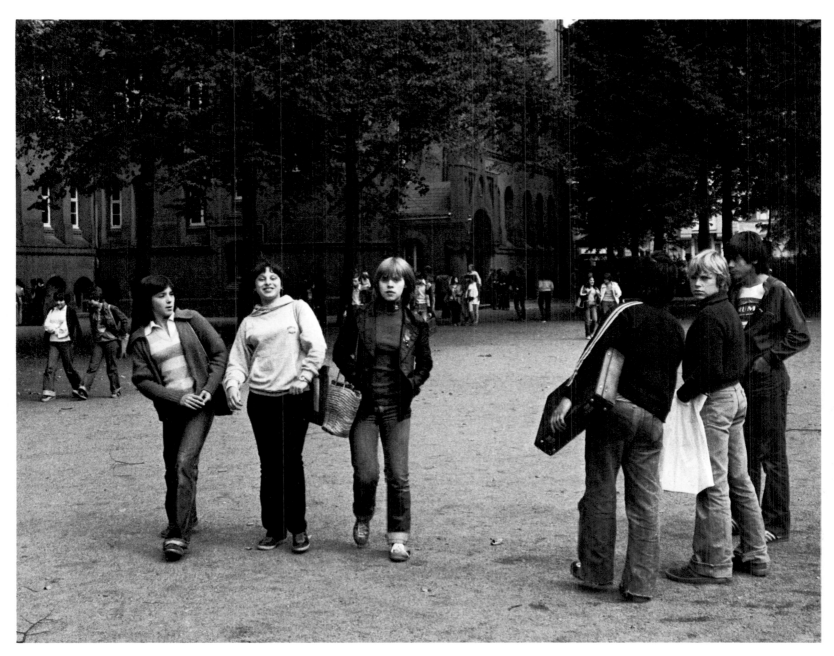

Children at Riesengebirgs-Oberschule, Schöneberg, West Berlin,
September 1979.

*This is how German youth looks today. To look at them, you'd think you were
in America. Needless to say, we dressed differently when I went to this very
school. It was called Hohenzollern Gymnasium, which seemed like a perfectly
good name for a school – much better than Riesengebirgs-Oberschule.*

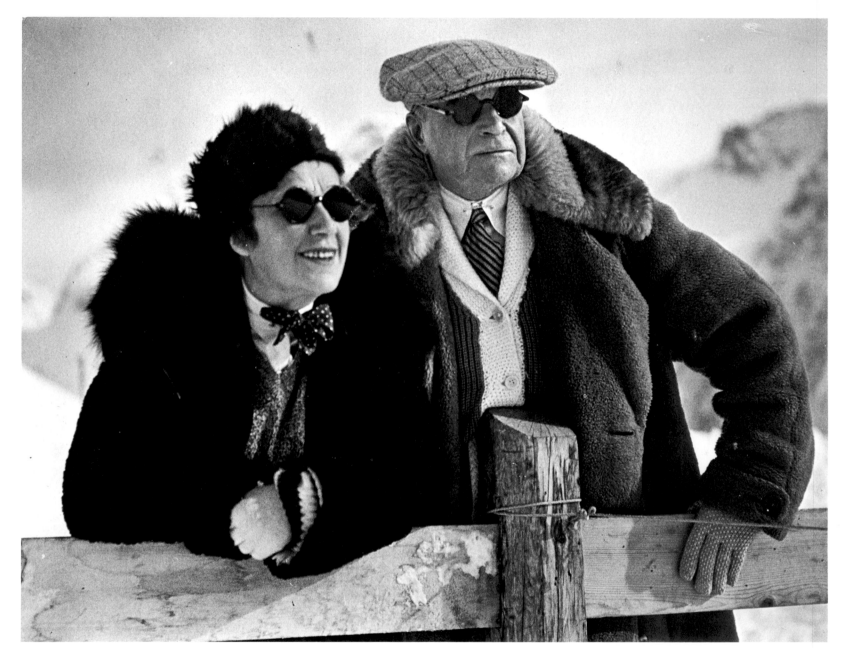

Albert Bassermann, winner of Germany's most prestigious acting award,
the Iffland Ring, with his actress wife Else, Arosa, 1932.

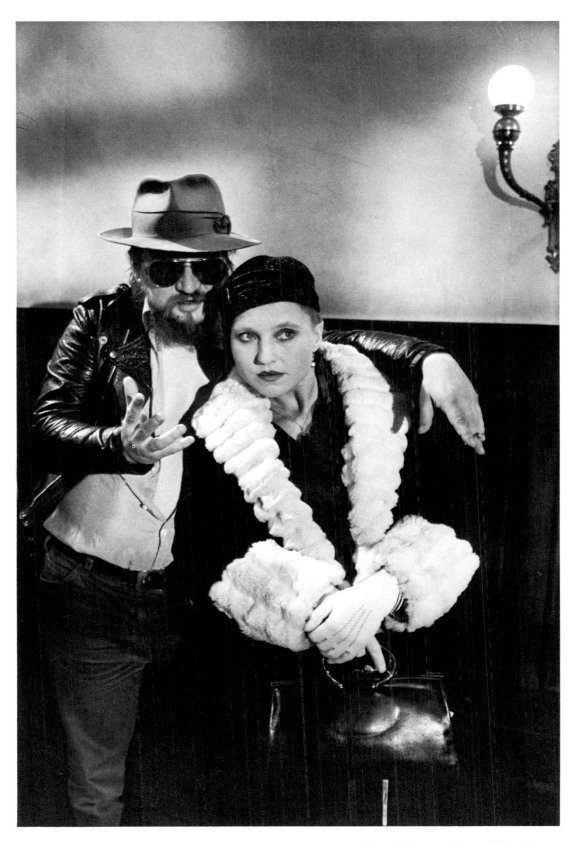

Director Rainer Werner Fassbinder with his star, Hanna Schygulla, on
the set of his film *Berlin Alexanderplatz*, Munich, April 1980.

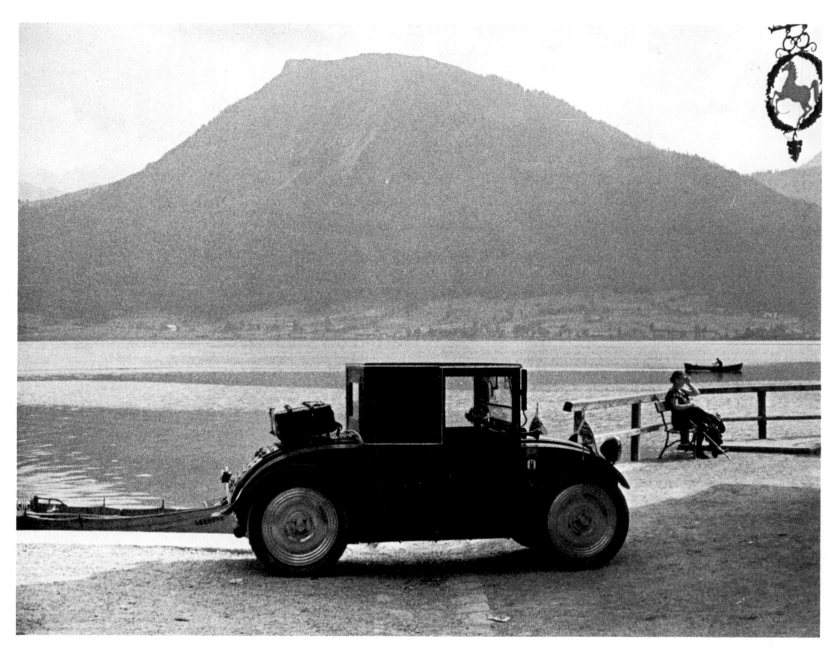

Hanomag car, Wolfgangsee, 1932.

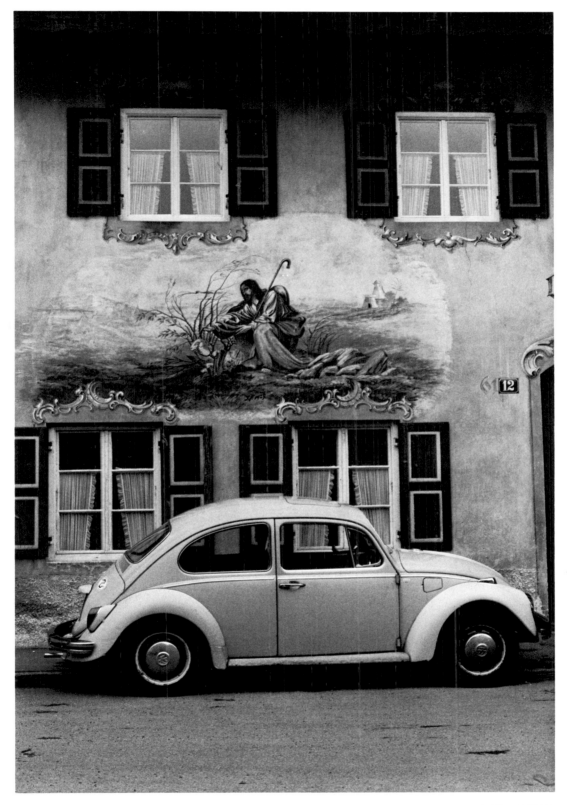

Volkswagen, Mittenwald, March 1980.

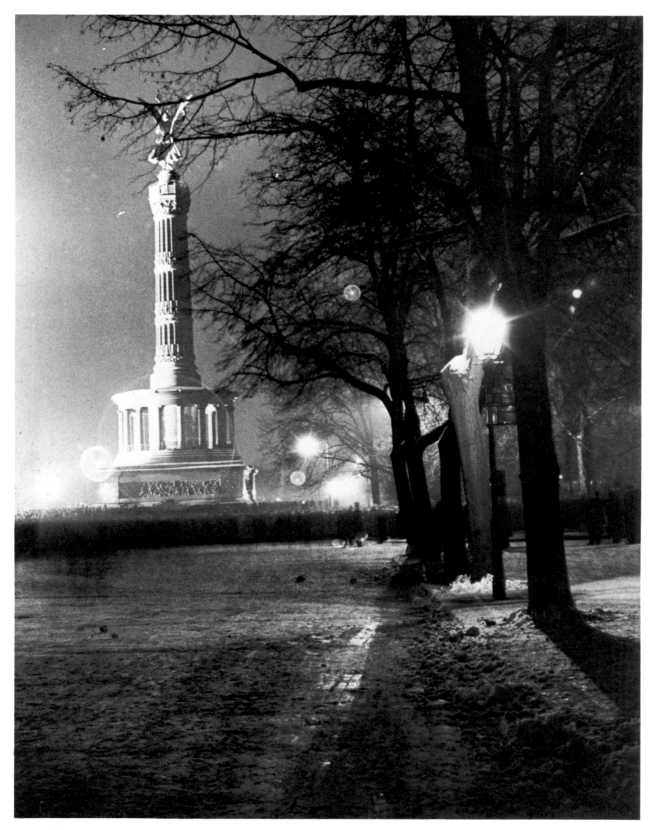

Demonstration in support of the Saar Plebiscite, Siegesallee, January 1934. Victory Column is in the background, Tiergarten is on the right.

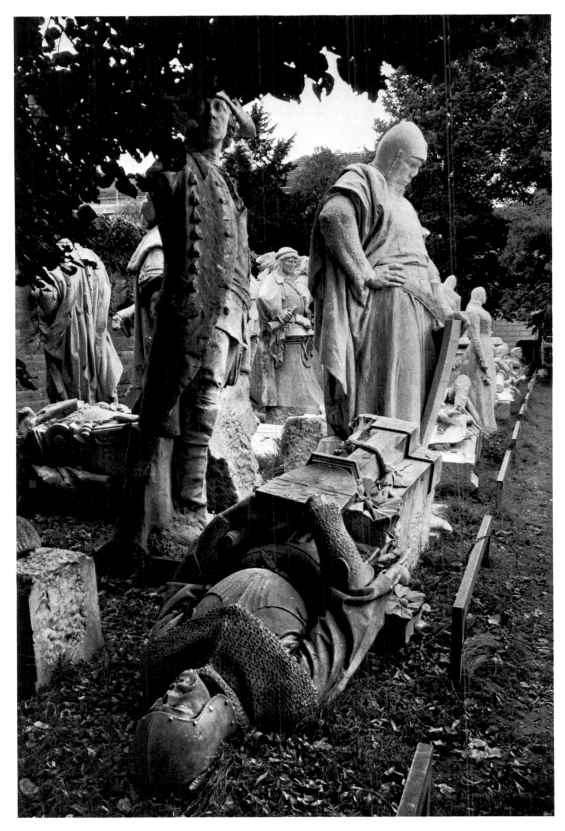

Marble statues in the garden of Bellevue Castle, West Berlin, 1979.

When I returned to Berlin, I kept looking for the statues that formerly lined
the Victory Alley from the Reichstag to the Victory Column. It turned out they
had been buried after the war and just dug up by chance in the Tiergarten
two months before we arrived. Here they all were, these monuments to German
history – Barbarossa, Beethoven, Frederick the Great with his chipped nose –
all in their statuary graveyard.

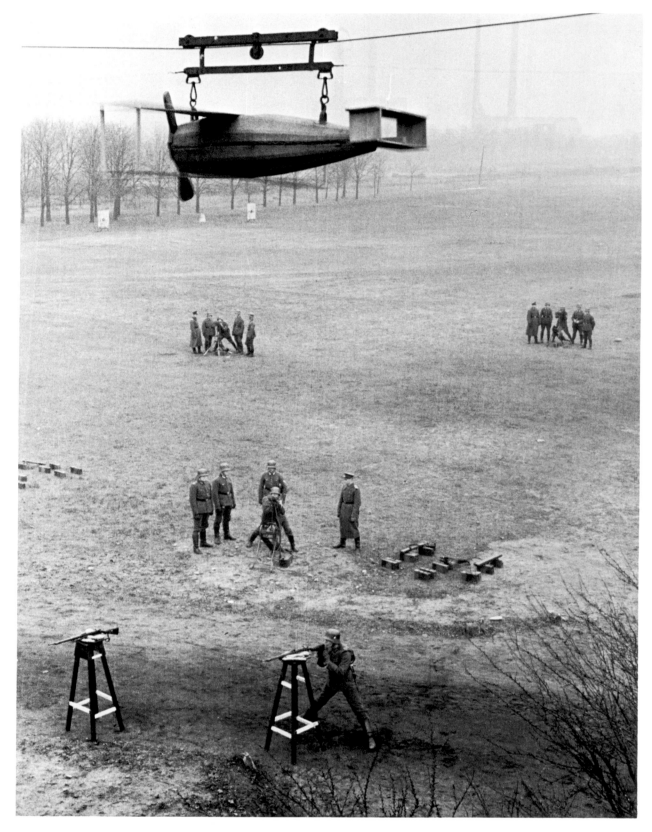

Mine-throwing unit, German Army, Spandau, 1934. Wooden planes
and dummies were in use as a result of the Versailles peace treaty.

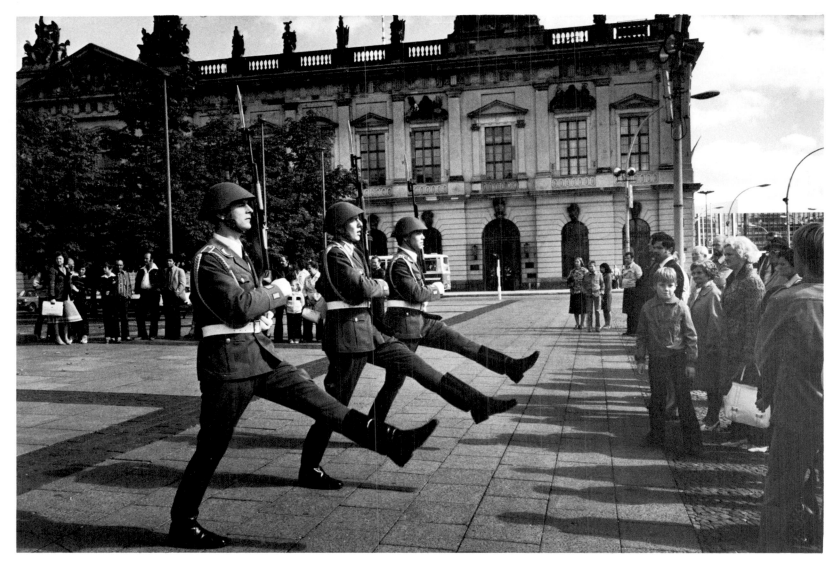

Changing of the guard, Tomb of the Unknown Soldier, East Berlin.
September 1979.

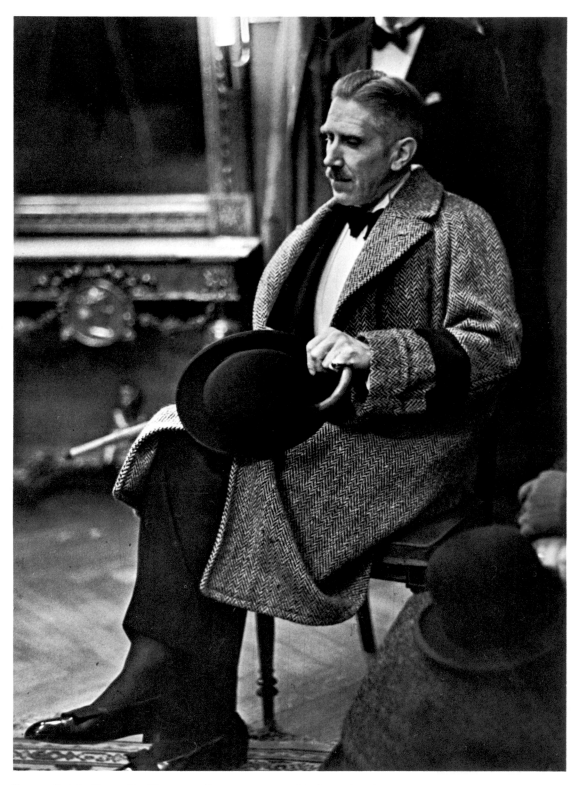

Former Reichs Chancellor Franz von Papen, wearing a black armband for
the late President Hindenburg, in the wings of the Berlin Philharmonic
during a recital by the 11-year-old violin virtuoso Ruggiero Ricci, Berlin,
1934.

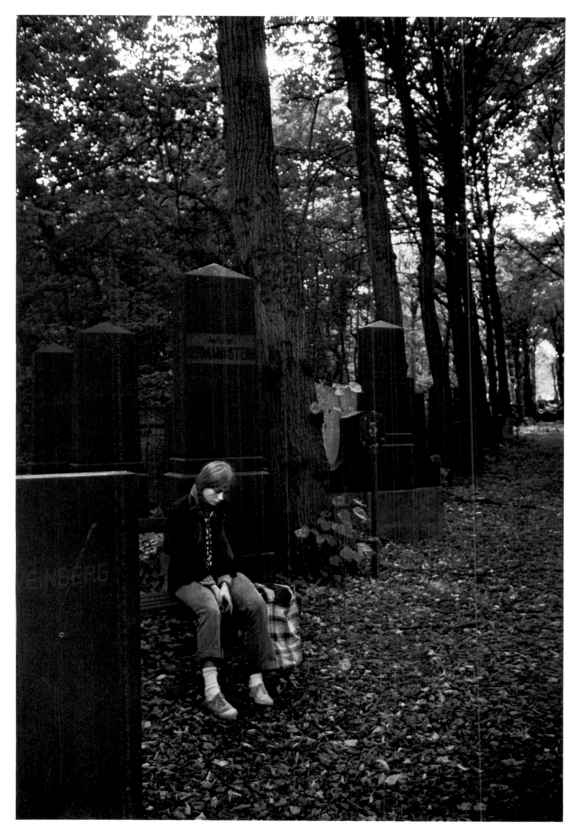

A girl in the Jewish cemetery, Weissensee, East Berlin, September 1979.

My father is buried here.

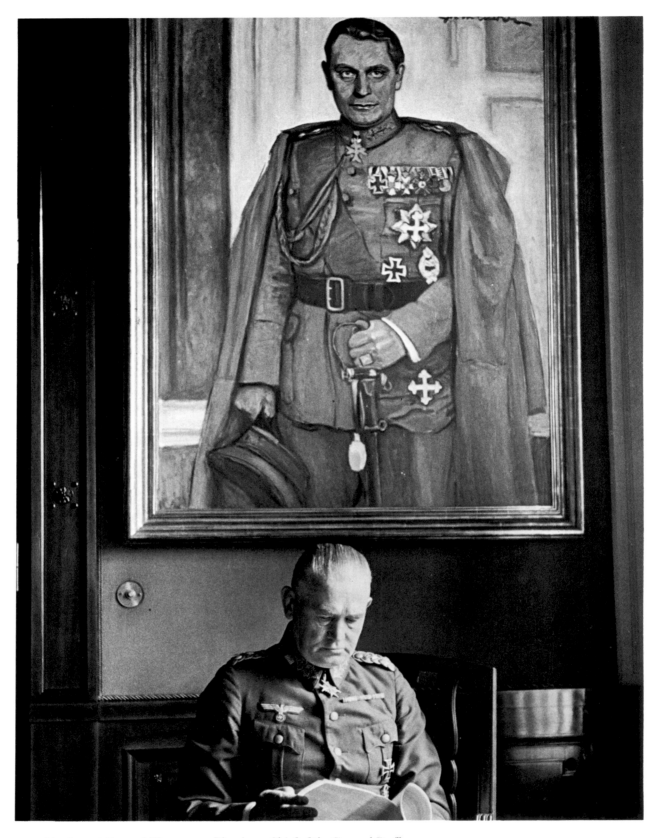

Lieutenant General Werner von Blomberg, Chief of the General Staff,
beneath a painting of General Field Marshall Hermann Göring, General
Staff Building, Berlin, 1934.

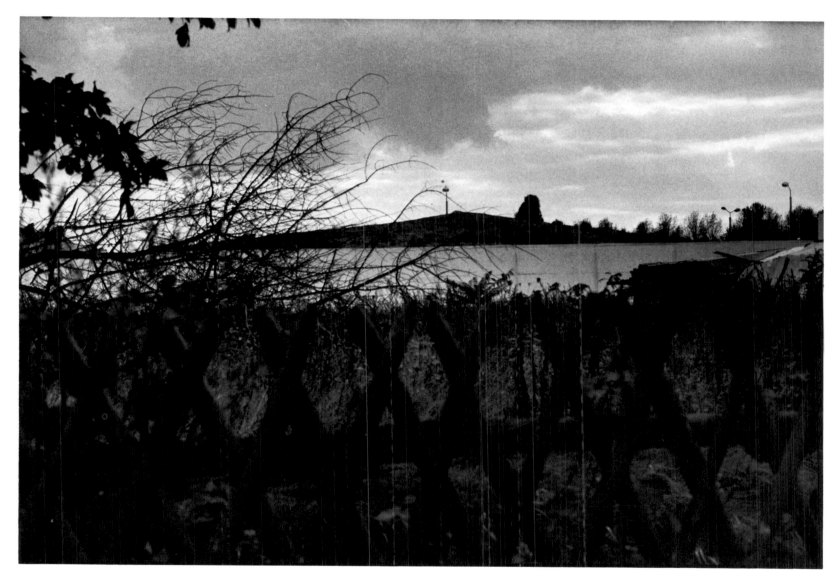

The bunker where Hitler died, seen from Otto Grotewohl Strasse, East
Berlin, September 1979.

*When I look at this picture, I think, "This is the end of the 1,000-year
German Reich." The photo was taken, coincidentally, from the exact spot
where the Reichs Chancellery stood on what was then Wilhelmstrasse.*

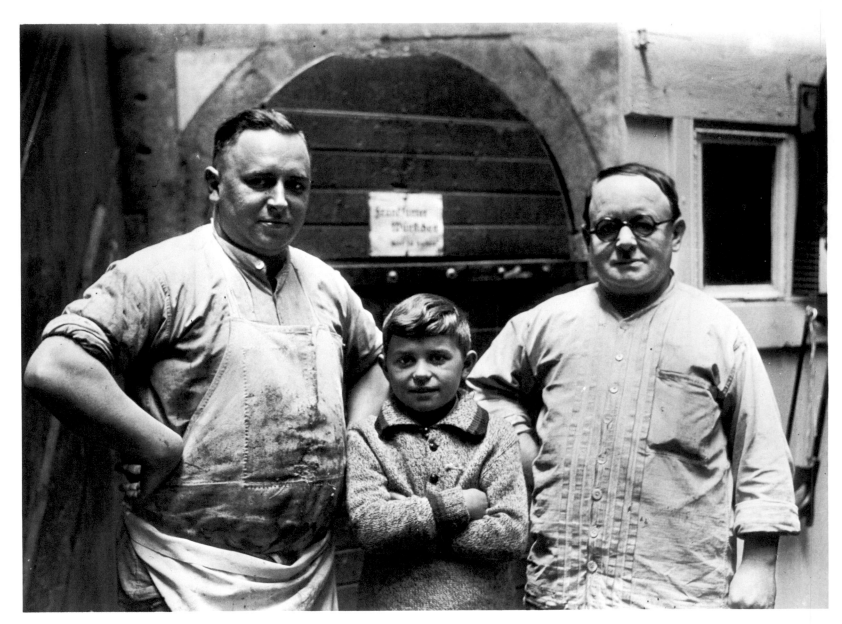

Albert Heim family, owners of store where the frankfurter originated,
Frankfurt, 1934.

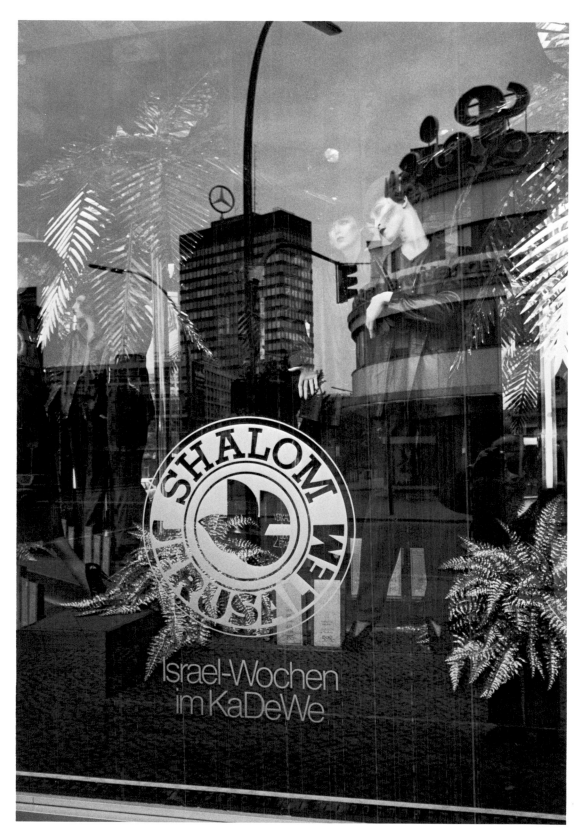

Israel Week promotion, KaDeWe department store, West Berlin,
September 1979.

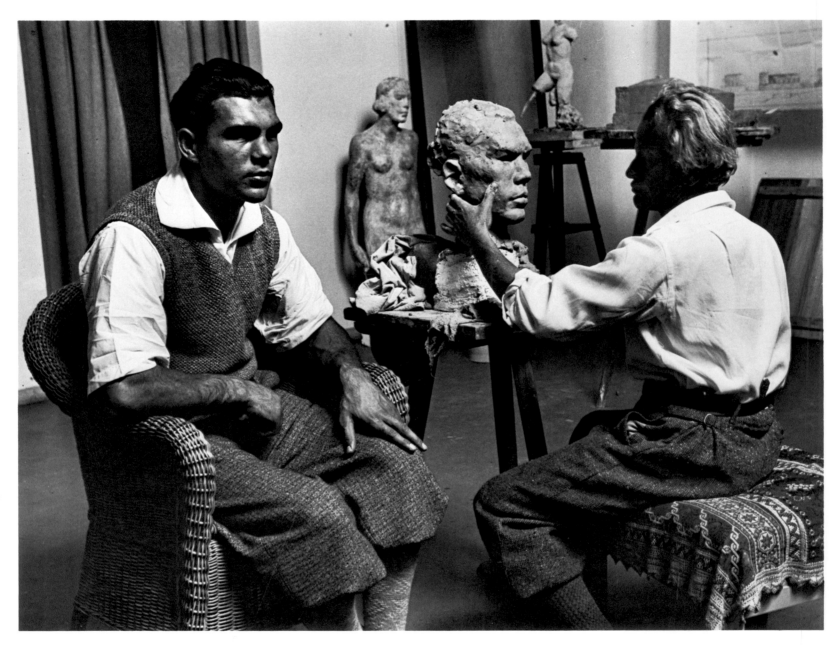

Max Schmeling, world heavyweight boxing champion, being sculpted
by Josef Thorak, Scharmützelsee, 1931.

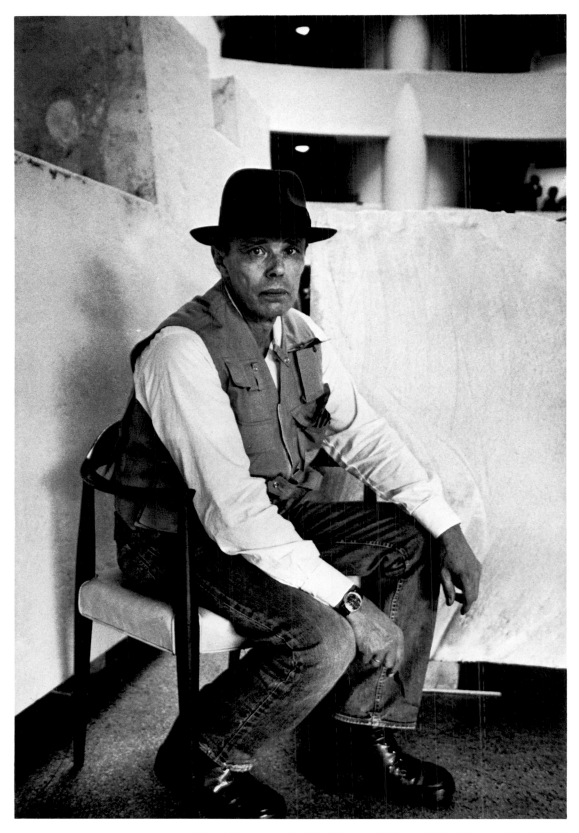

Joseph Beuys, artist, The Solomon R. Guggenheim Museum, New York, November 1979.

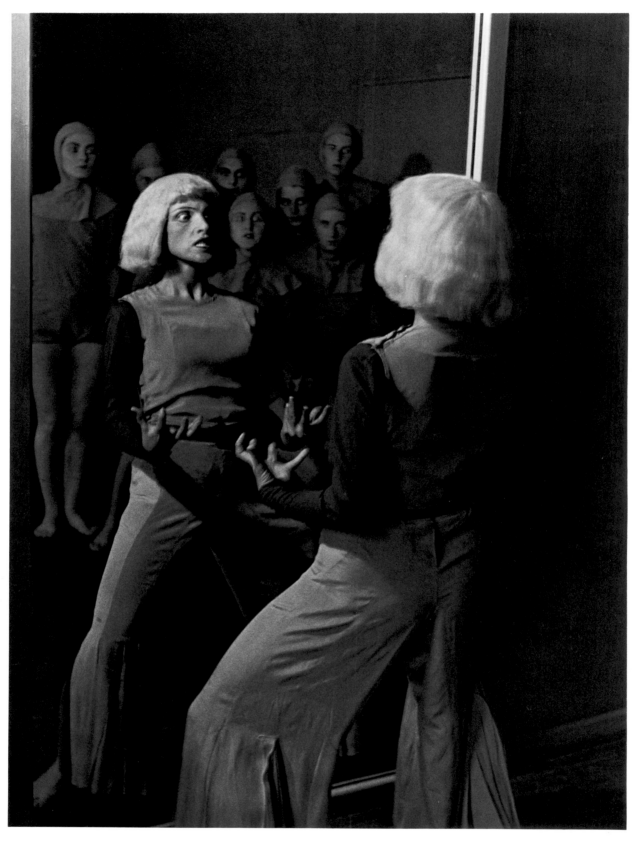

Truempy Ballet School, Berlin, 1931.

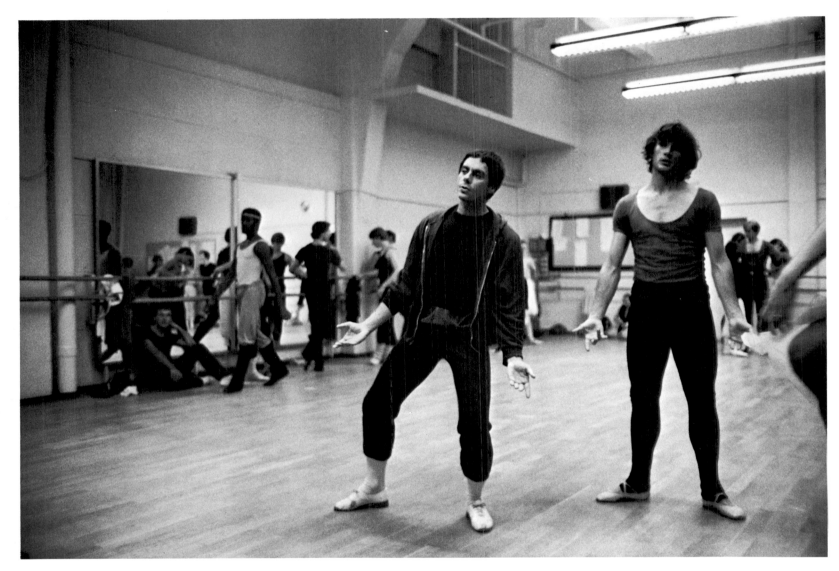

John Neumeier, director, Hamburg Opera Ballet, with dancers from
company, Hamburg, September 1979.

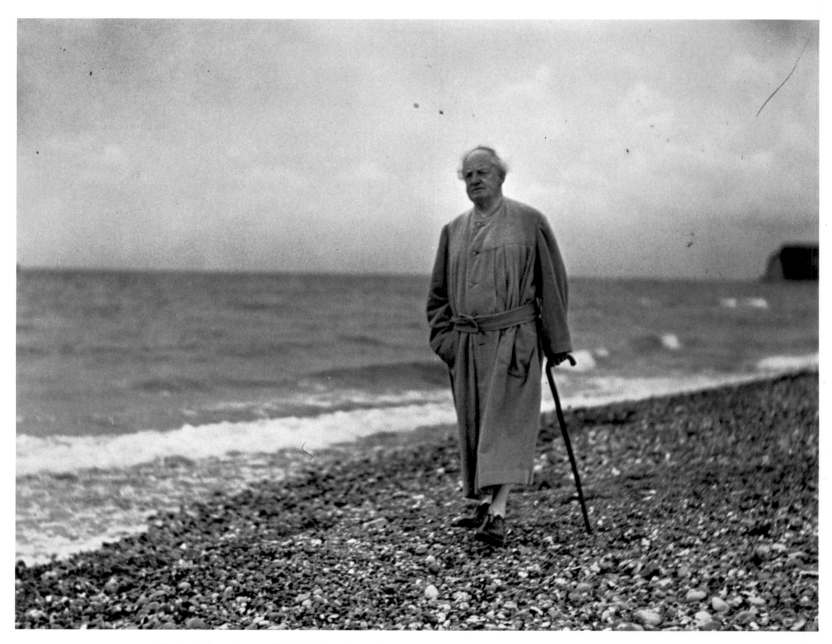

Gerhart Hauptmann, Nobel Prize winner for literature. Island of
Hiddensee, 1931.

*This photograph, incredibly enough, was totally unposed. I simply
photographed Hauptmann, looking Goethe-like, on his daily walk on the edge
of the Baltic Sea.*

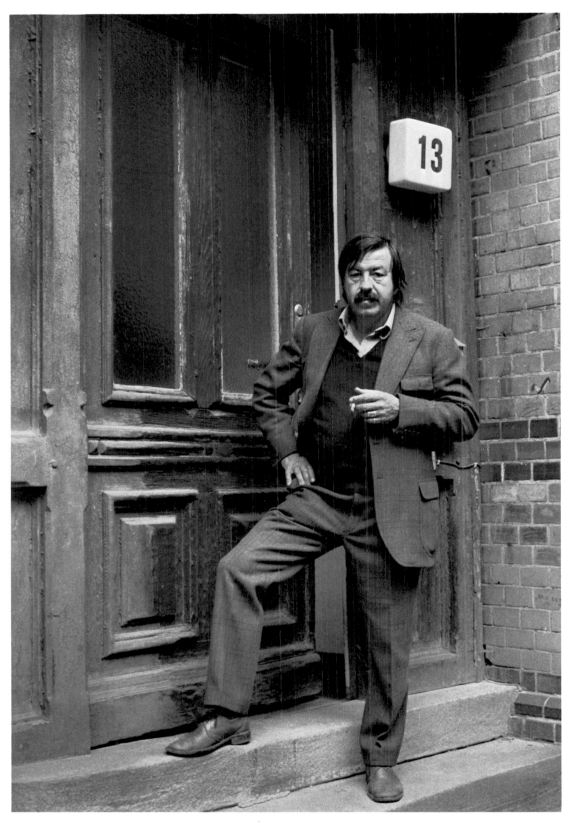

Günter Grass, West Berlin, September 1979.

I was pleased with many of the photographs I took of Günter Grass in his atelier, surrounded by his etchings, his sculptures, and his books. But this picture – perhaps because of the door which he chose to leave charred after the neo-Nazis burned it in the 1950s – has an added dimension.

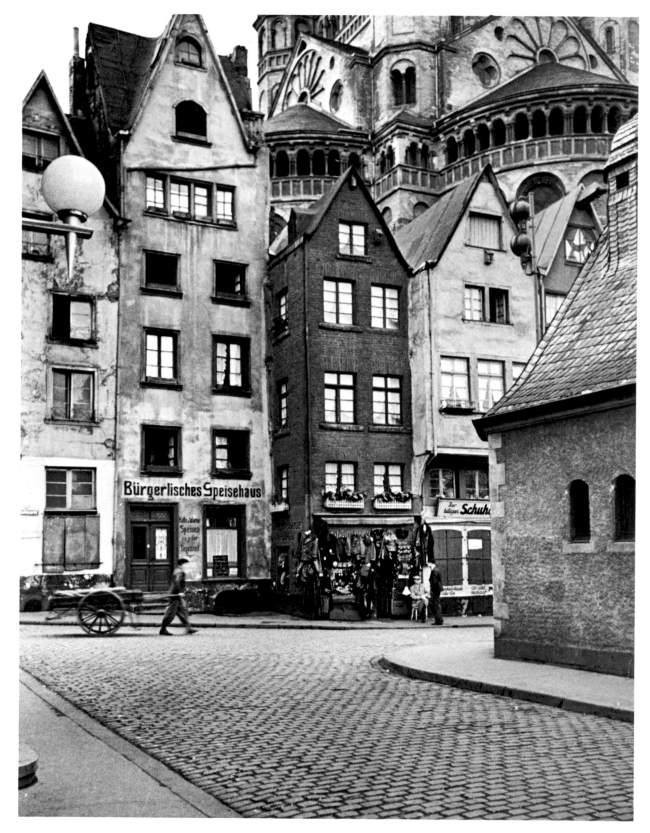

Old Town, Cologne, 1934.

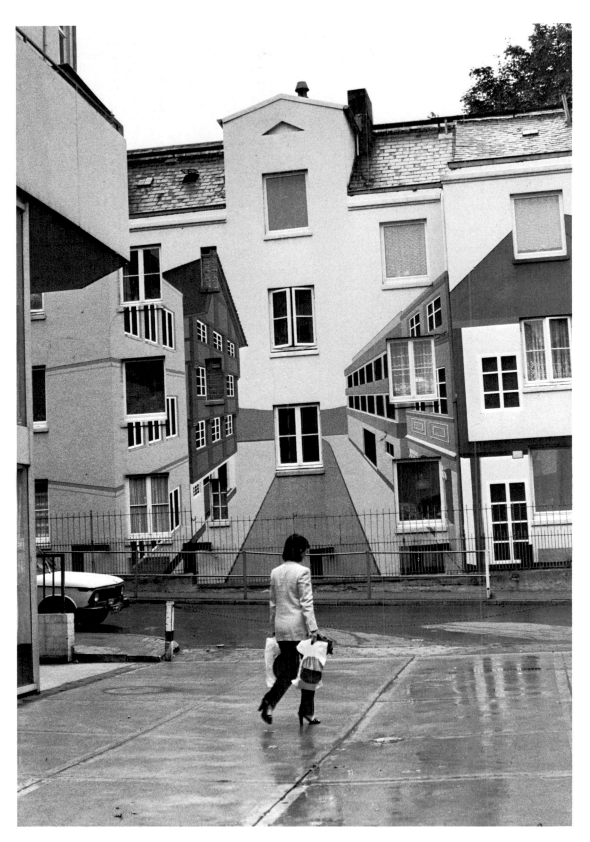

Building with trompe l'oeil, Pöseldorf, Hamburg, September 1979.

Until someone elegant walked into the frame, this wasn't a picture for me. Sometimes I've waited hours for a person, a dog, or a cat to appear and add the needed detail to a picture. For a photographer, the most important thing to have is patience.

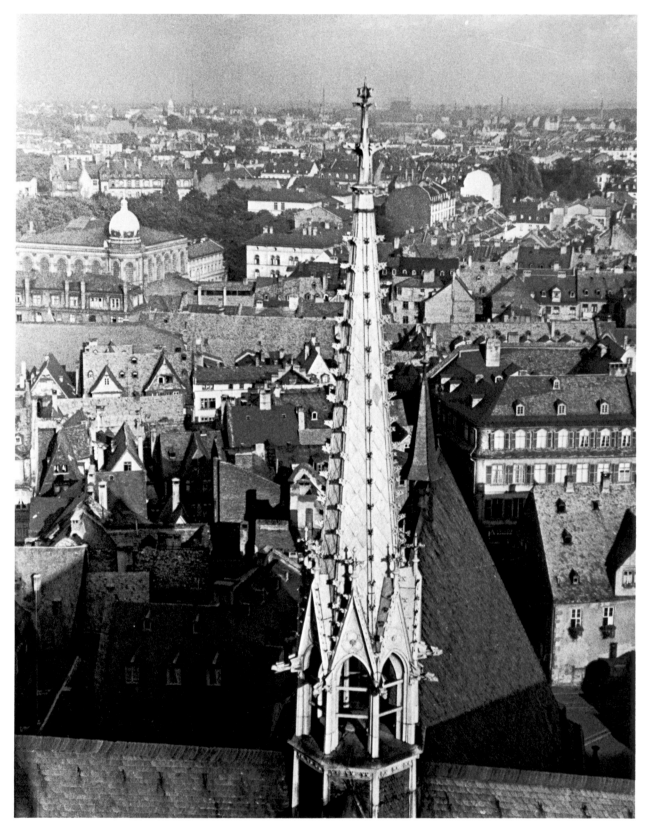

Spire of Frankfurt Cathedral and Old Town, 1934.

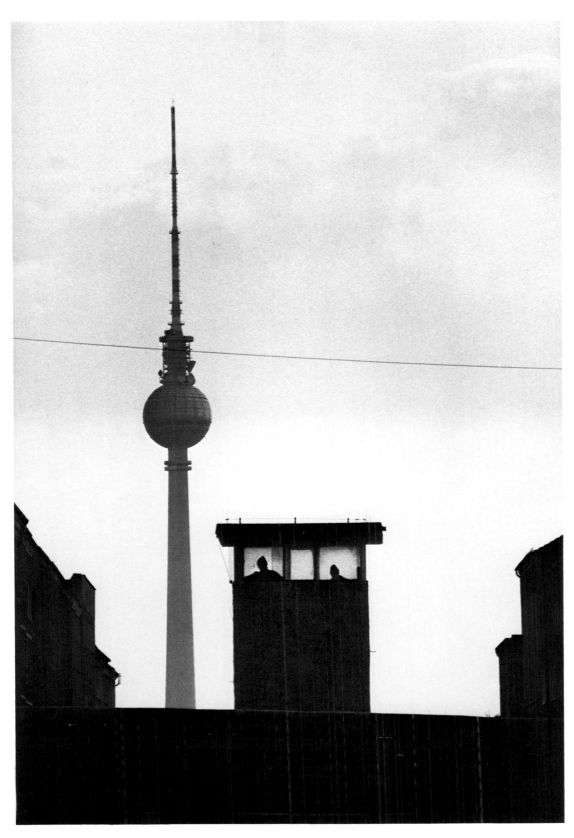

Watchtower manned by East German guards and television tower, photographed from West Berlin, September 1979. Berlin Wall is in foreground.

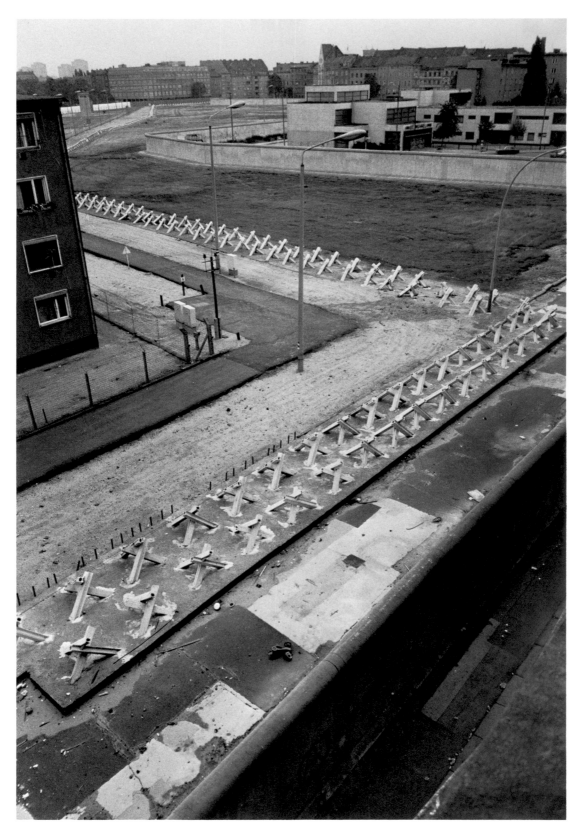

No man's land, a mined area beyond the Berlin Wall, East Berlin,
September 1979. The photograph, taken from a building in West Berlin,
includes a portion of the Western sector beyond the curving Wall.

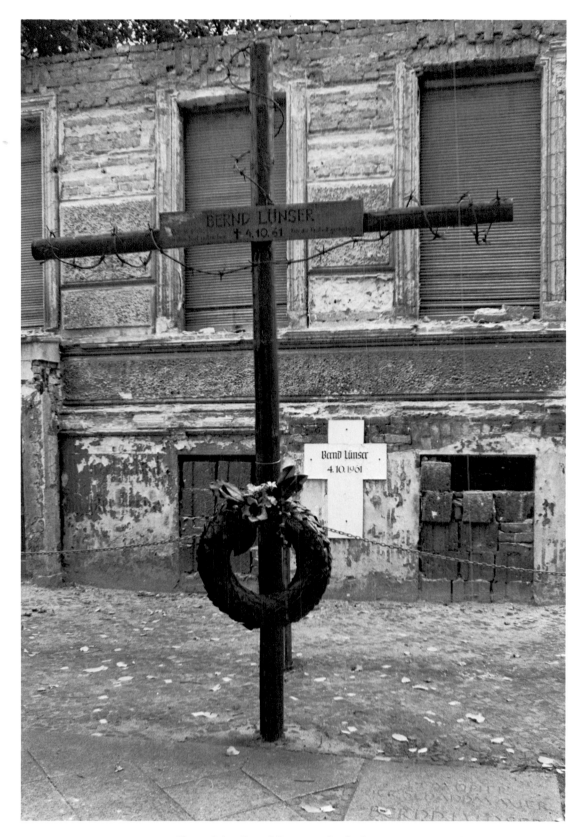

Memorial to Bernd Lünser, who died in October 1961 while escaping
from the window of a building being used as part of the original Wall,
West Berlin, September 1979.

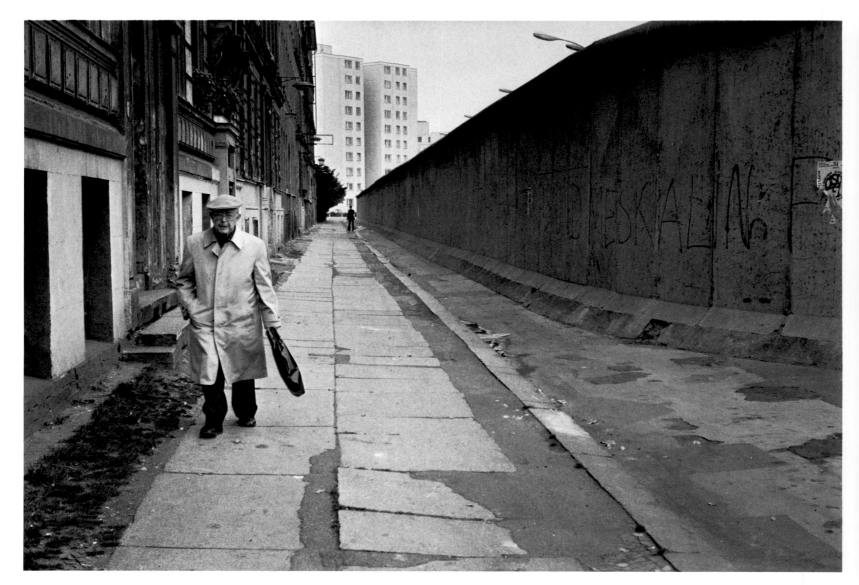

Luckauer Strasse, West Berlin, September 1979. The street is bounded
on the right by the Berlin Wall.

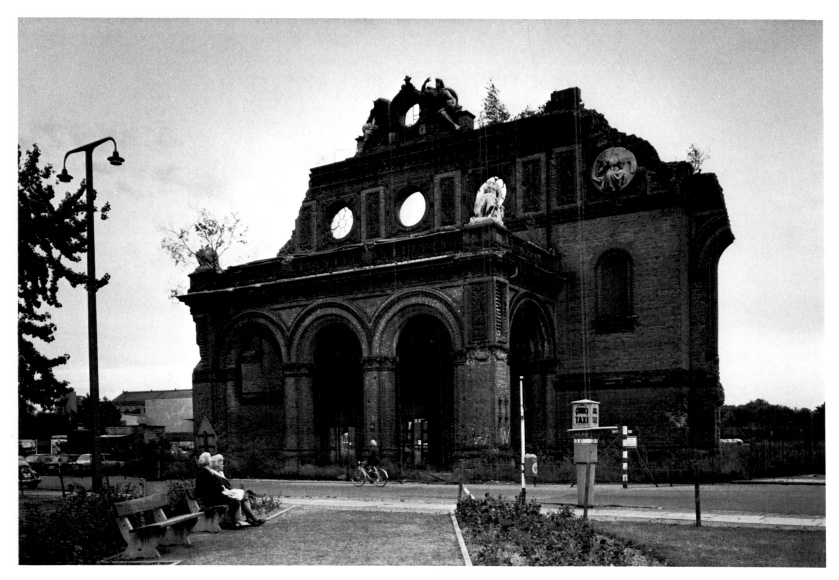

Anhalter Bahnhof, West Berlin, September 1979.

From the Anhalter Bahnhof you could get to France, Russia, the whole world.
I left through these portals in 1916 as a soldier in the German Army. I came
back with shrapnel in both legs. Then, maybe ten years later, I took my second
published picture here – it was nine in the morning, the station was full of
steam, and a ray of sunlight was striking an old woman's head.

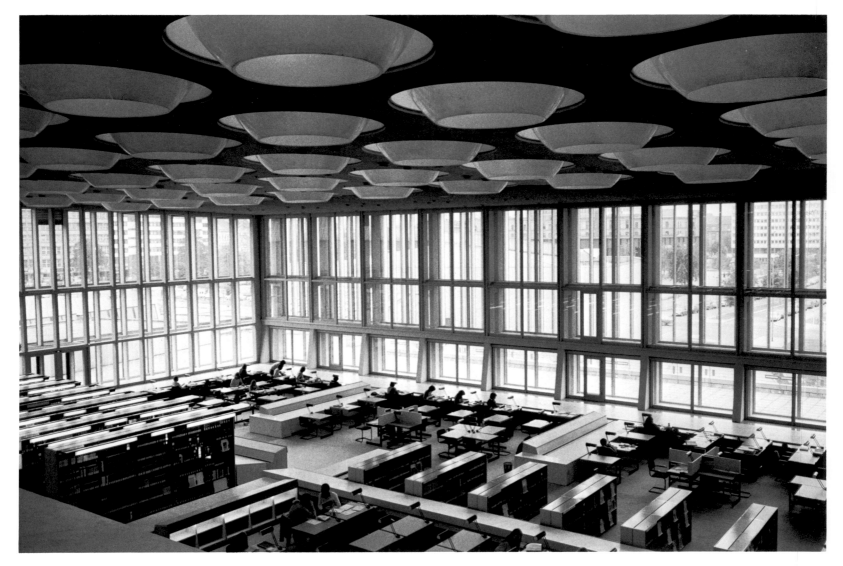

Neue Staatsbibliothek, West Berlin, September 1979.

Leninplatz, East Berlin, September 1979.

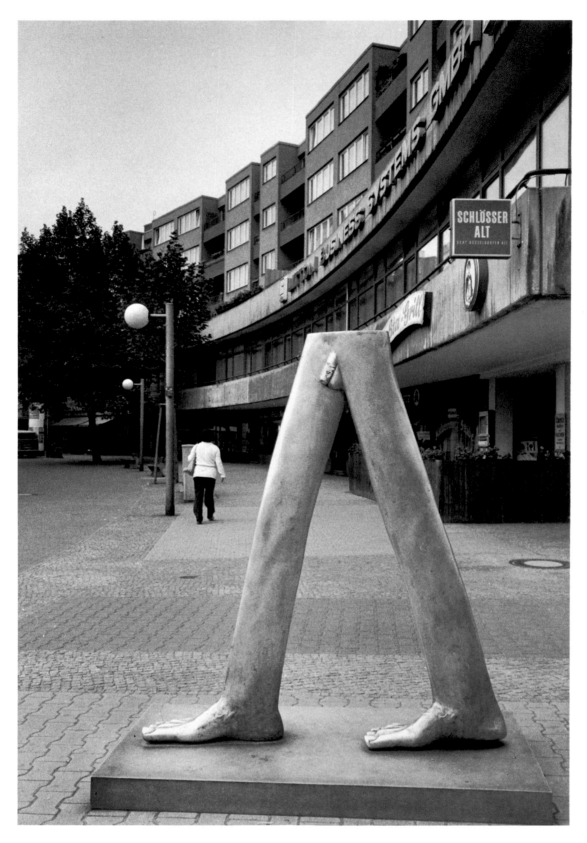

Statue, Hallesches Tor, Kreuzberg, West Berlin, September 1979.

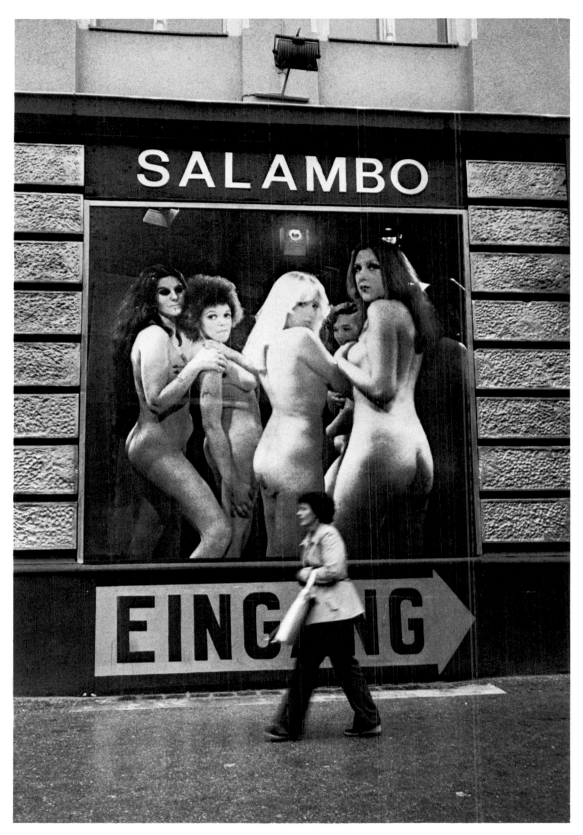

Salambo, night club, Kurfürstendamm, West Berlin, September 1979.

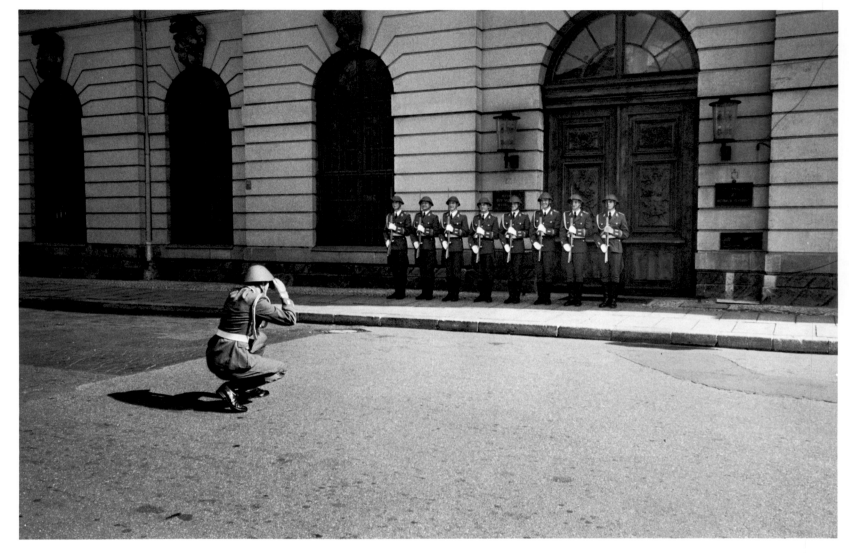

East German lieutenant photographing color guard opposite Tomb of the
Unknown Soldier, East Berlin, September 1979.

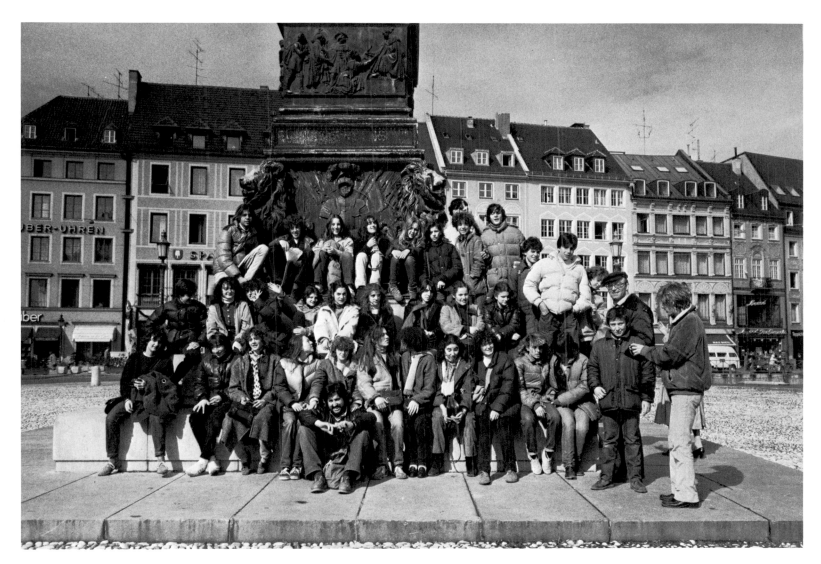

German school children posing at base of monument to Max Joseph,
late King of Bavaria, Max Joseph Platz, Munich, March 1980.

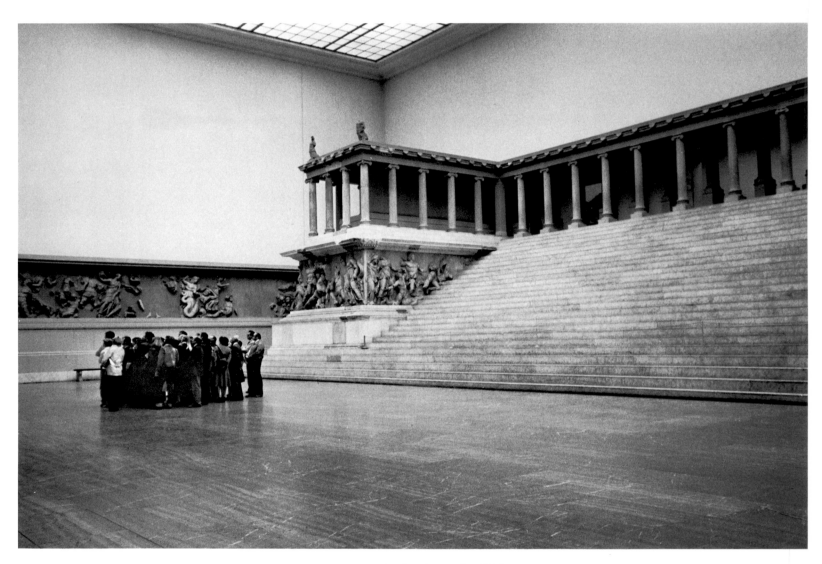

Pergamon Altar, Pergamon Museum, East Berlin, September 1979.

When I was young, I often went to see this altar – the most impressive sight imaginable within a museum. Then, after I became a photographer, in 1934 I went to Turkey with Swedish Crown Prince Gustav Adolf and the Royal Family, and we visited Pergamon, from which the altar had been brought.

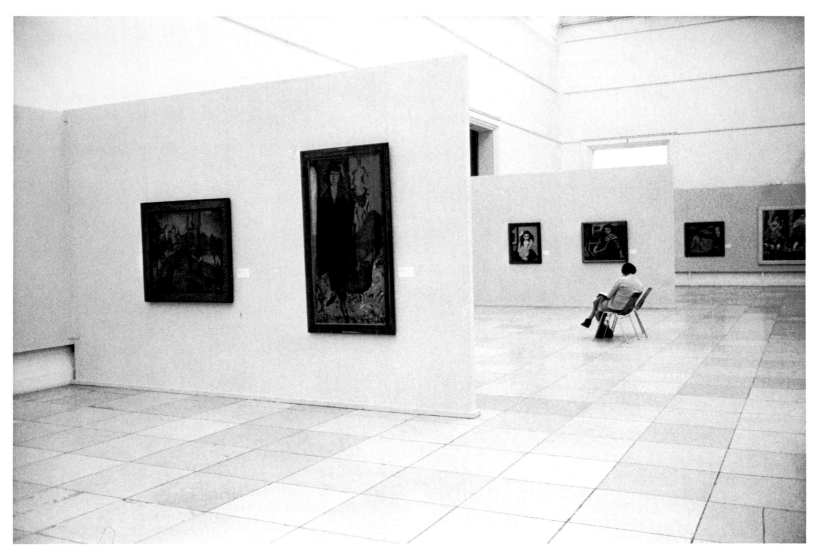

Ernst Ludwig Kirchner exhibition, Haus der Kunst, Munich, April 1980.

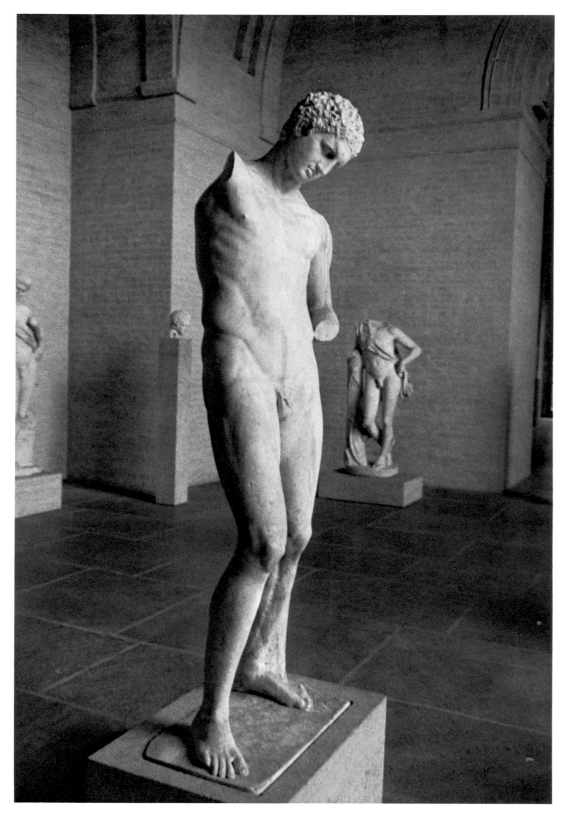

Greek statue, Glyptothek, Munich, April 1980.

Rainer Werner Fassbinder, film director, Munich, April 1980.

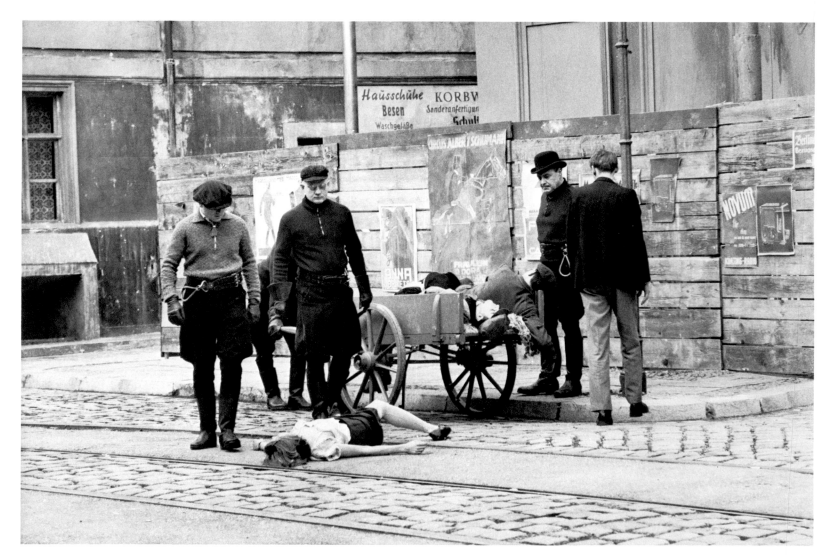

A dream sequence from Fassbinder's film *Berlin Alexanderplatz*, Munich, April 1980.

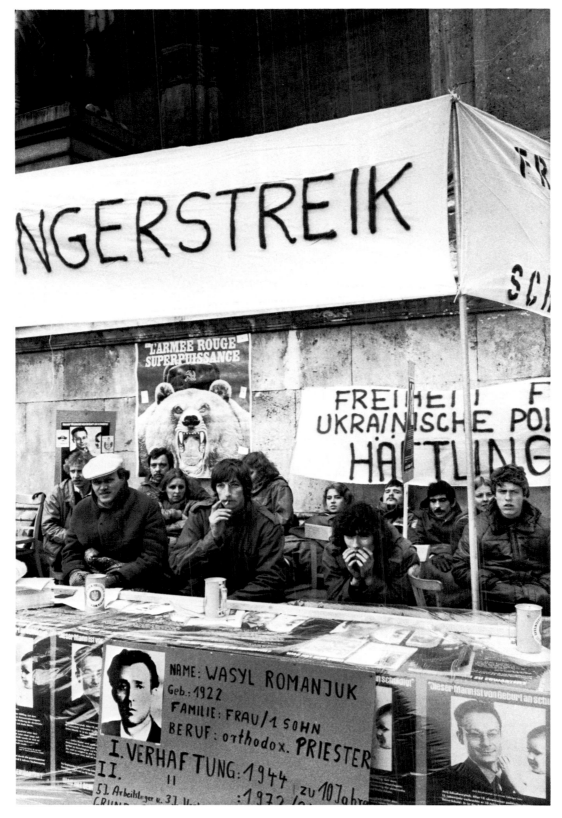

Demonstrators advocating freedom for Ukrainian political prisoners in
the U.S.S.R., Odeonsplatz, Munich, March 1980.

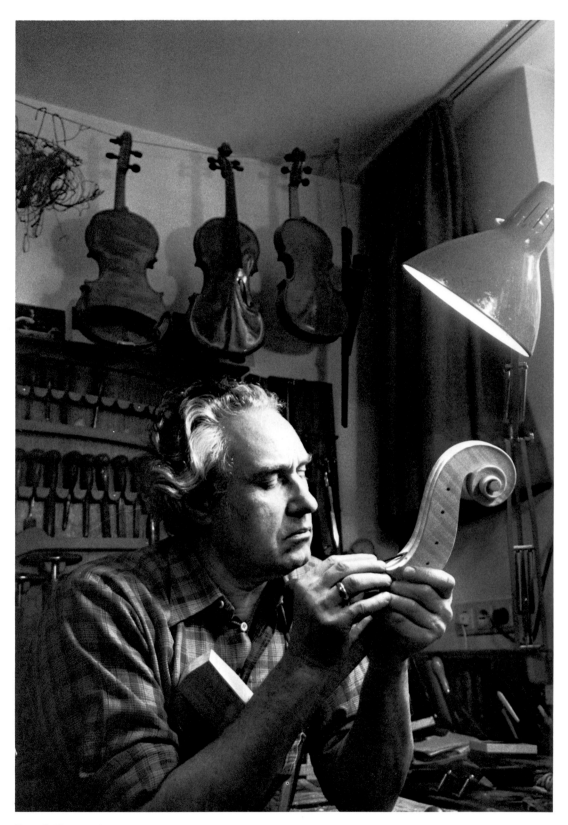

Joseph Kantuscher, master violinmaker, Mittenwald, March 1980.

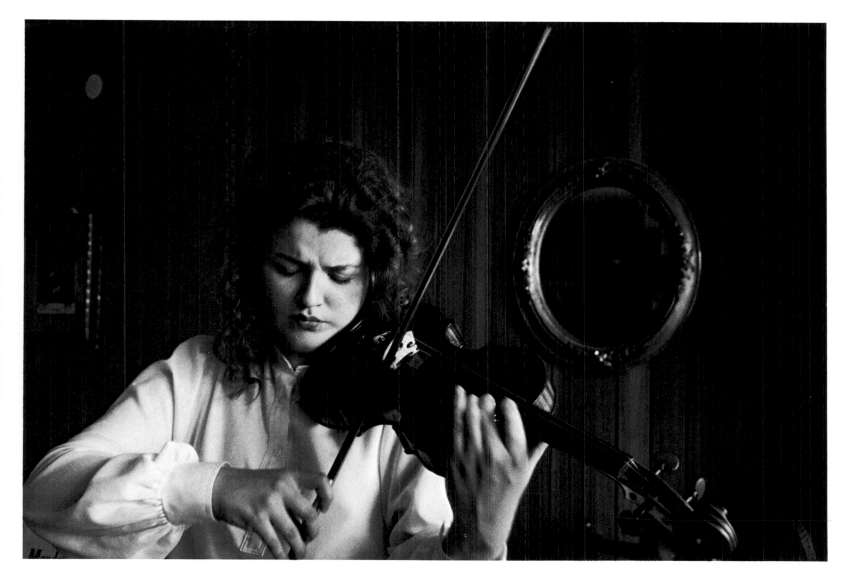

Anne-Sophie Mutter rehearsing Beethoven's Violin Concerto on her
Stradivarius at her home in Wehr, near the Black Forest, March 1980.
The 16-year-old protégée of Herbert von Karajan has recorded three works
with him.

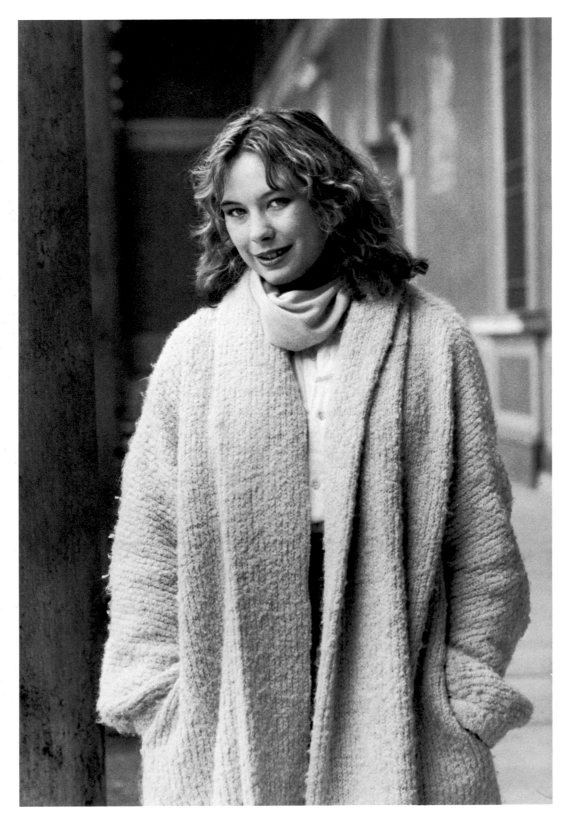

Ala, Princess von Auersperg, Munich, April 1980.

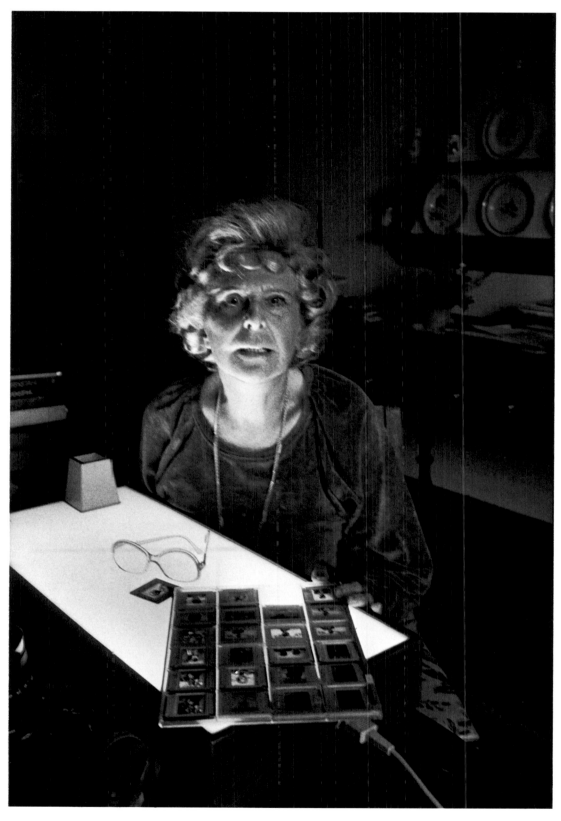

Leni Riefenstahl, photographer, Munich, March 1980.

In New York, people were always asking me, "Why do you want to
photograph Leni Riefenstahl?" The answer is simple: I have great
admiration for her talent.

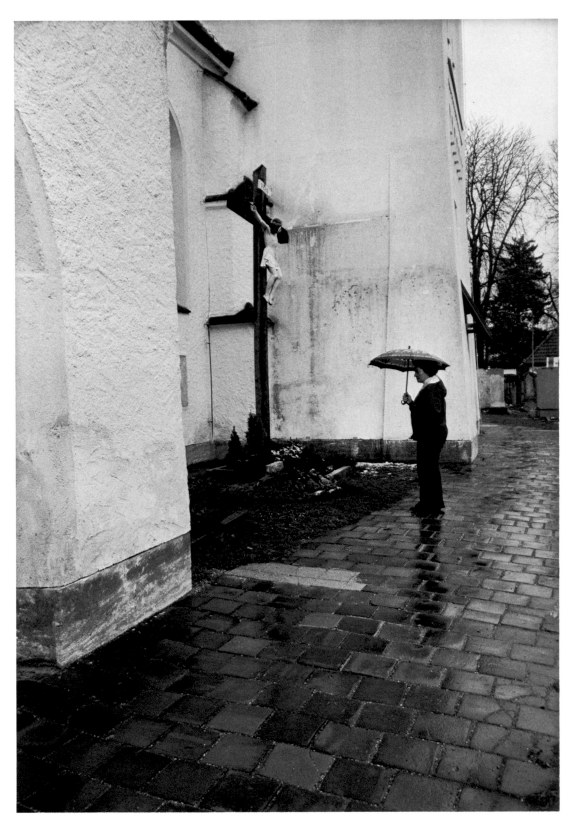

Crucifix outside the St. Martinskirche, Munich-Obermenzing, April 1980.

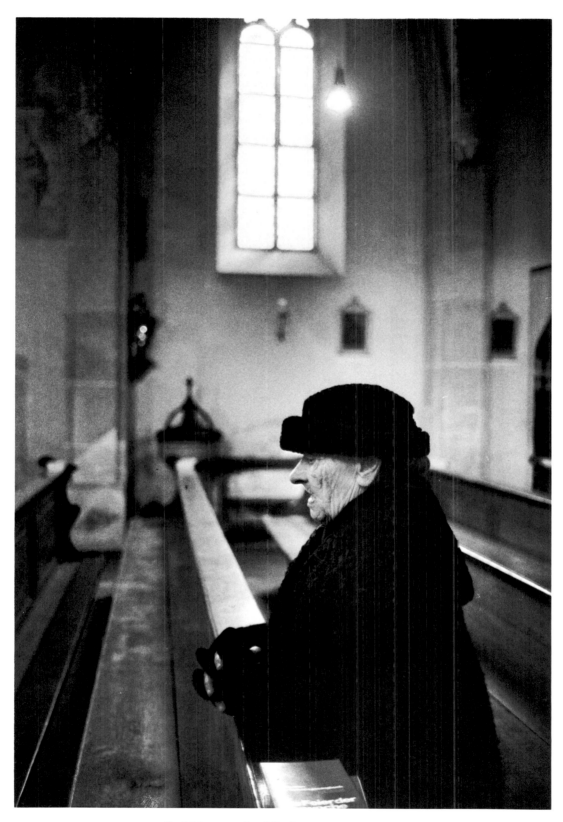

Parishioner at Good Friday observance, the St. Martinskirche, Munich-Obermenzing, April 1980.

When I entered the church, the priest made a speech for the assembled congregation about how I had left Germany during the Nazi period and had finally returned after forty-four years. He said the church was honored to have me there. I was quite moved.

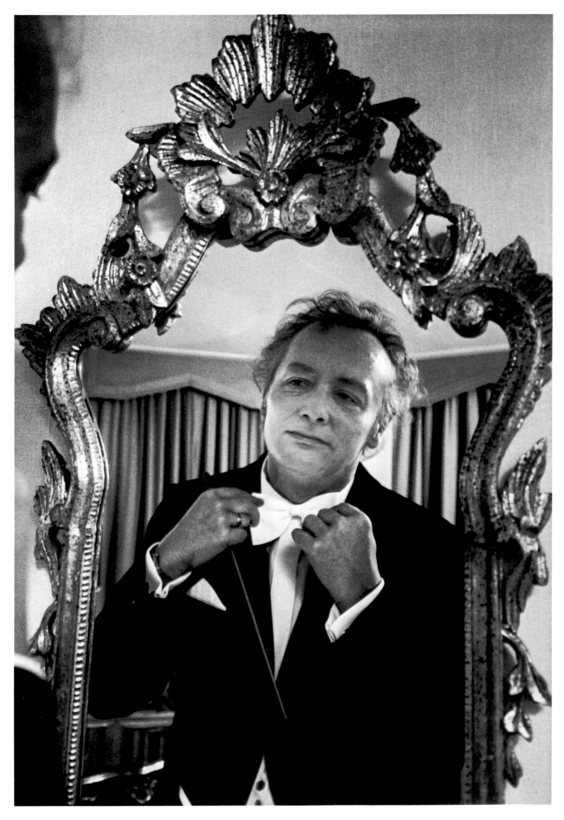

Klaus Tennstedt, conductor, Munich, March 1980.

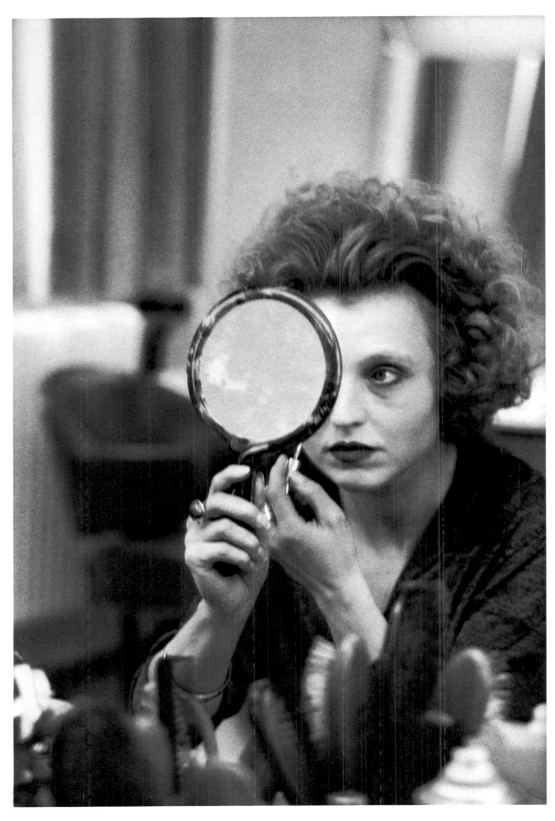

Hanna Schygulla, actress, Munich, April 1980.

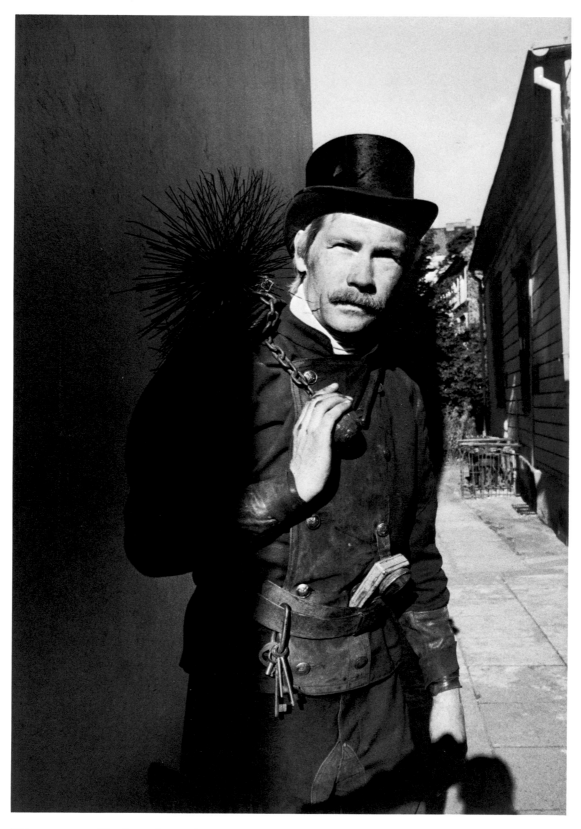

Chimney sweep, Hamburg, September 1979.

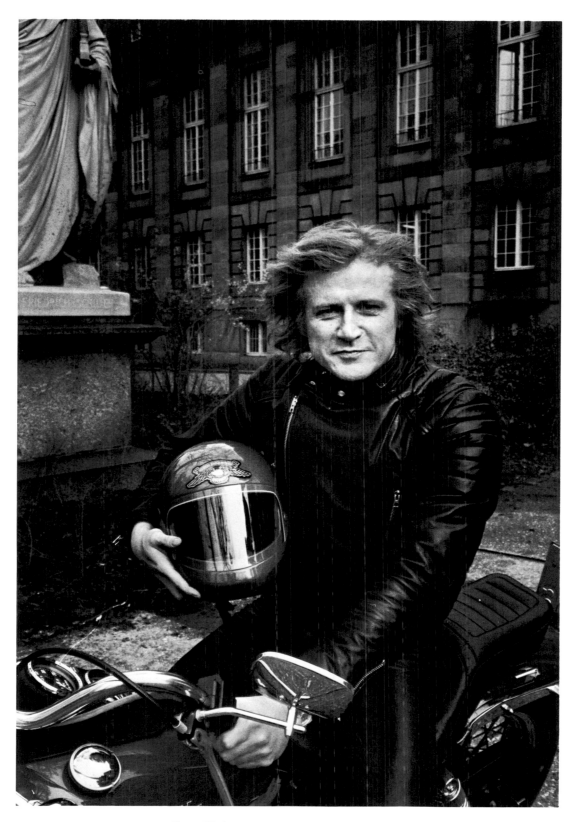

Peter Hofmann, Wagnerian tenor, outside Stuttgart Opera House, April 1980. After appearing as Tristan or Parsifal, Hofmann indulges in his hobby: racing his Harley-Davidson motorcycle.

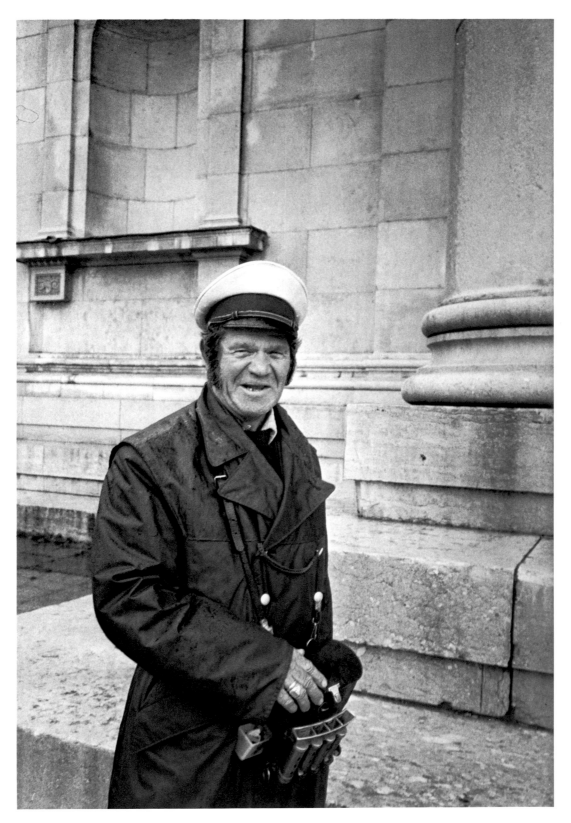

Alfred Meller, parking-lot attendant, Haus der Kunst, Munich, April
1980.

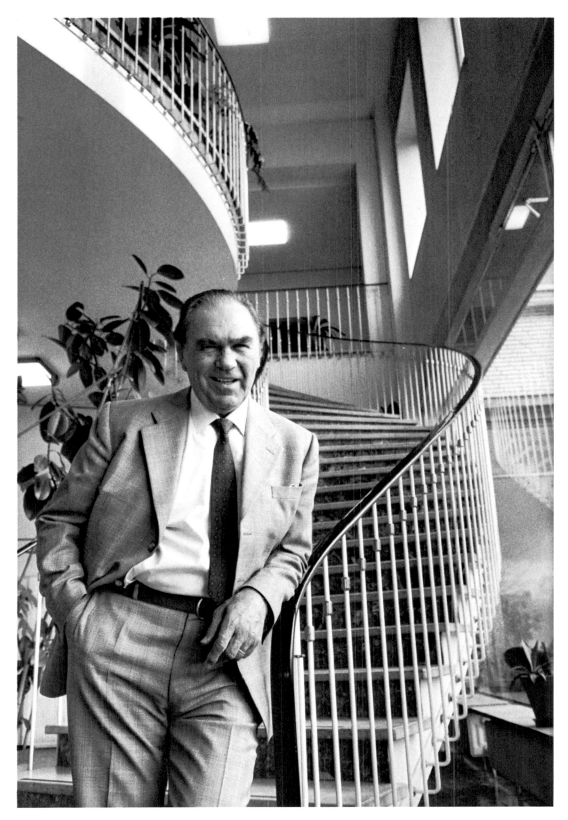

Max Schmeling, President, Max Schmeling Coca-Cola Bottling Company,
Bramfeld, Hamburg, April 1980.

*Fifty years ago, Schmeling was the German hero – the Muhammad Ali of his
time. And see how fine he looks: at seventy-five, he cycles twenty kilometers a
day on a stationary bike while watching television at home; he's in good
health; and like Riefenstahl – and me – he's still working.*

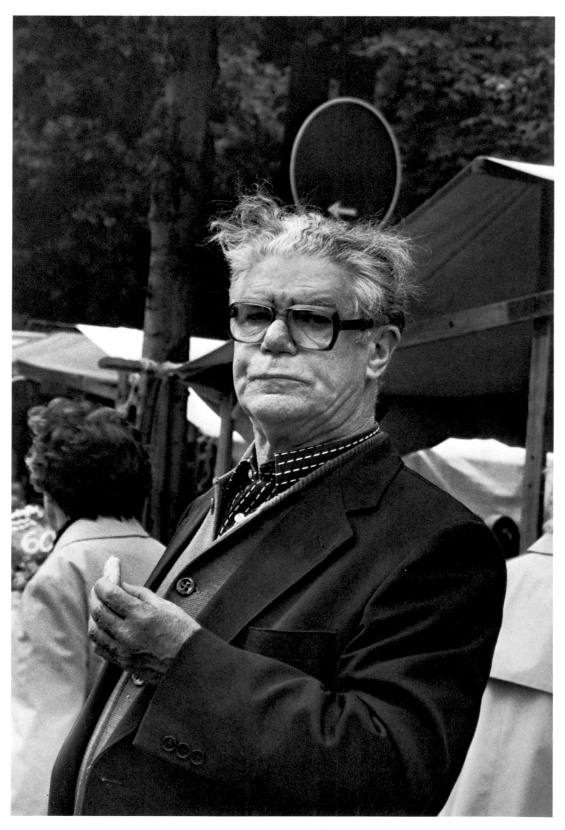

Man in marketplace, John F. Kennedy Platz, Schöneberg, West Berlin,
September 1979.

Theo Sommer. Editor. *Die Zeit*, September 1979.

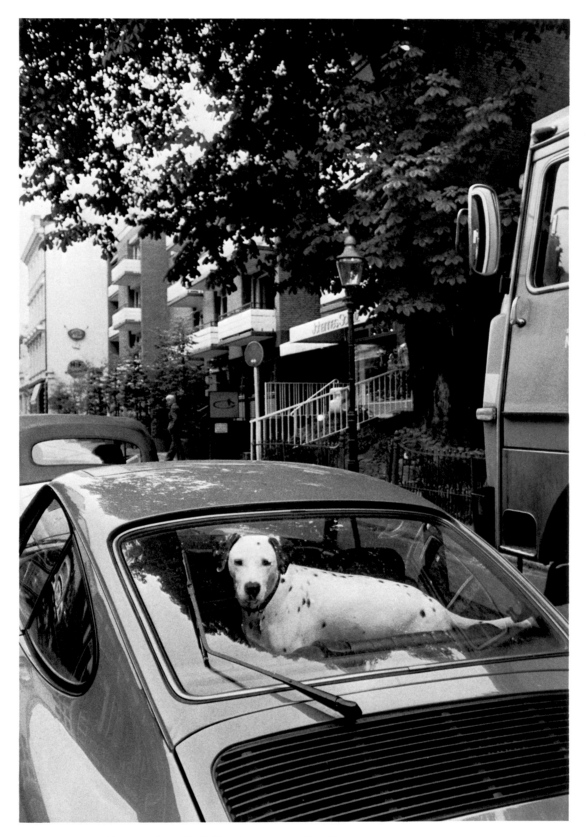

A Dalmatian in a Porsche, Pöseldorf, Hamburg, September 1979.

The dog had to fill up the whole frame. If it had been a toy poodle, it wouldn't have made a picture.

Alfred Eisenstaedt has frequently been described as the father of photojournalism. In fact, he was one of a handful of pioneers who developed photoreportage in the late 1920s and early 1930s, coincident with the emergence of the high-speed Leica camera.

Eisenstaedt was born in Dirschau, West Prussia, in 1898. His father, a retired department-store owner, moved the family to Berlin in 1906, and the Eisenstaedts remained there for the next twenty-nine years. Eisenstaedt served in the German Army in World War I and suffered shrapnel wounds in both legs during the German offensive in Dieppe.

He began doing free-lance photography in the 1920s while employed as a button and belt salesman. While still a free lancer, he was assigned to cover major conferences and balls by the Associated Press and various German publications. On his own initiative, he also covered concerts, sports events, and other newsworthy activities. He became a professional photographer in 1929, and his first assignment was to cover the Nobel Prize ceremony in Stockholm, at which Thomas Mann became Nobel laureate for literature. Thereafter Eisenstaedt traveled widely – to the Swiss resorts where the wealthy and titled gathered; to the capitals of Europe, where he photographed leaders and great events (among them, the first meeting of Hitler and Mussolini); and to Ethiopia on the eve of war with Italy.

After leaving Hitler's Germany in 1935, he helped to introduce photojournalism to the United States. He became, along with Margaret Bourke-White, one of *Life*'s original four photographers – and remained with the magazine for the next forty years. During that time, he had some 2,000 assignments and more than 90 *Life* covers. He became especially known for his photographs of people – Winston Churchill, Charles Chaplin, Richard Strauss, Gerhart Hauptmann, Sophia Loren, John F. Kennedy. He treated the famous and the anonymous with equal care and perception.

Eisenstaedt's photographs have appeared in almost every major photography magazine and in many photo anthologies. Among the books devoted to his photographs are *Witness to Our Time*, *The Eye of Eisenstaedt*, *People*, *Witness to Nature*, *Martha's Vineyard*, *Eisenstaedt's Album*, and *Eisenstaedt's Guide to Photography*. He has received numerous honors, and his work has been exhibited widely in galleries. In 1976 the Knoedler Gallery in New York commemorated his fiftieth year as a photographer with a comprehensive exhibition of his work.

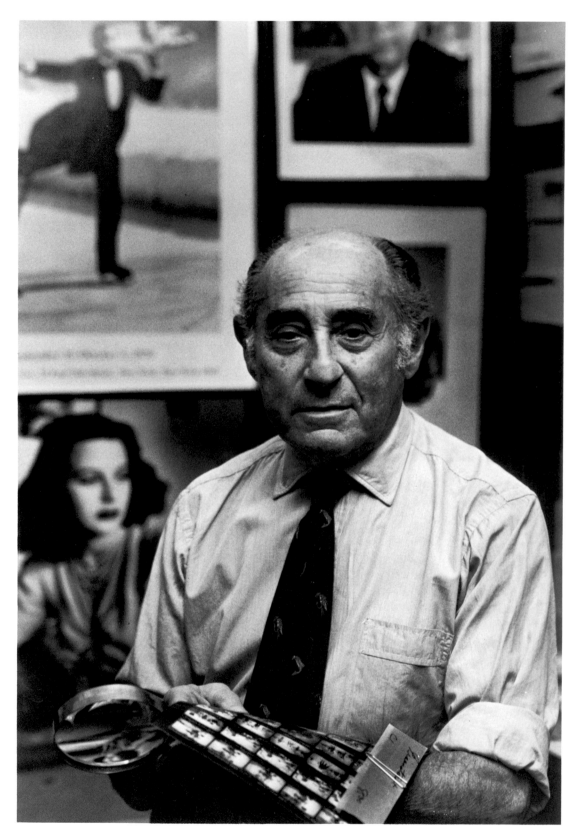

Alfred Eisenstaedt

Photograph by Frank White

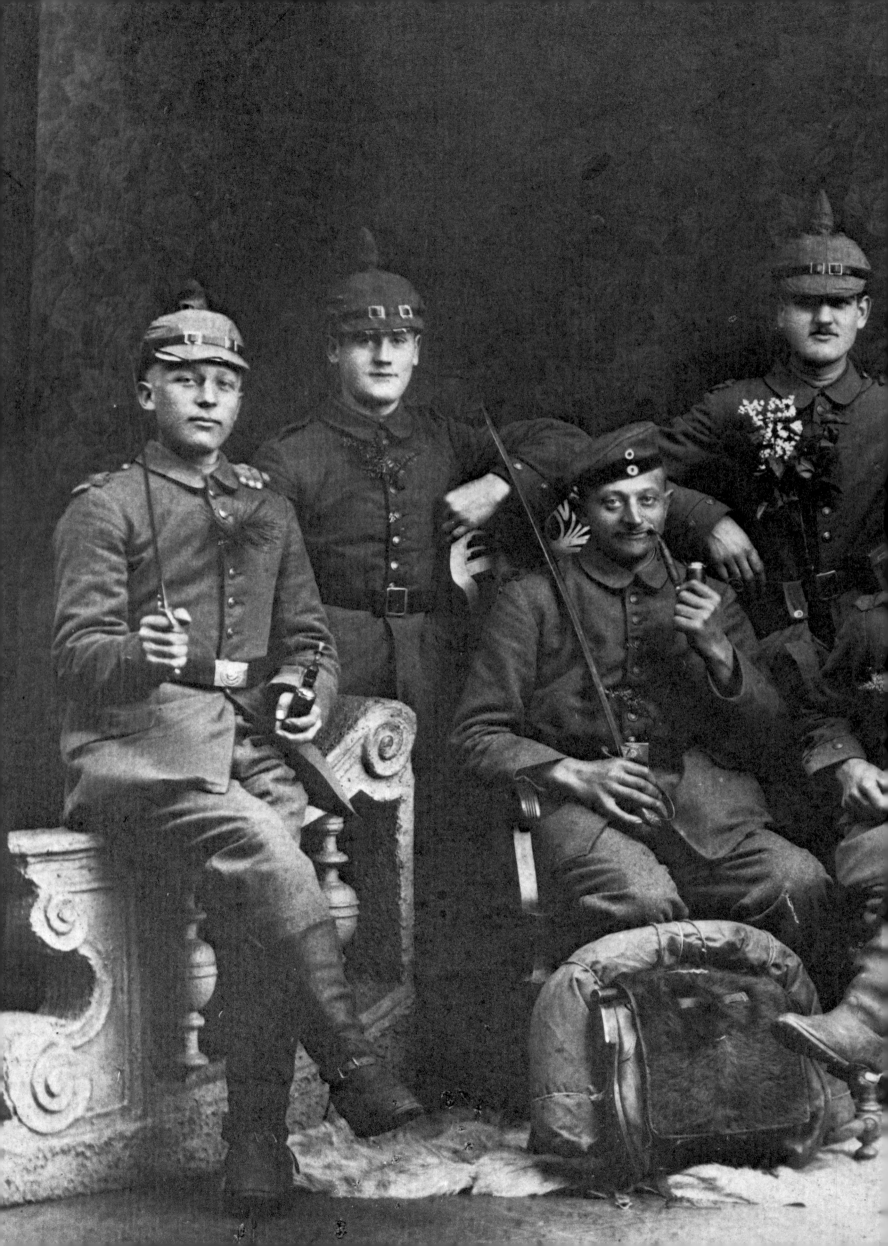